IMAGES of America
CHARLES COUNTY REVISITED

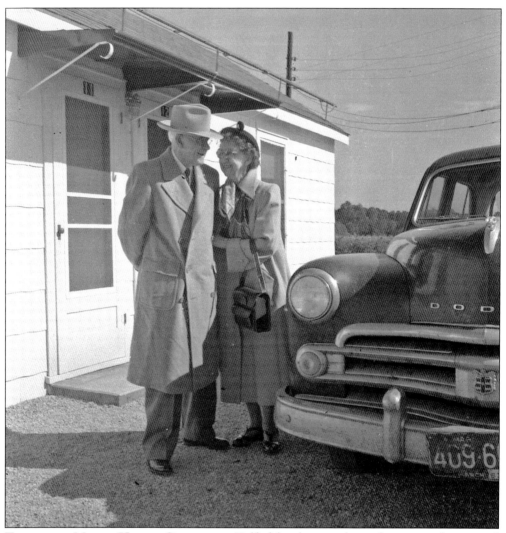

THOMAS AND MAXINE HEADEN COLLECTION. Half of the photographs used to convey the pictorial history of Charles County come from the new Headen Collection in the Southern Maryland Studies Center (SMSC) at the College of Southern Maryland campus in La Plata. The images are incredible and the content wonderfully diverse. Thomas Headen was the editor of the weekly newspaper, the *Waldorf Leaf*, established in 1953. When the *Times Crescent* purchased the *Waldorf Leaf*, Headen continued as the paper's editor while working on projects for the college until his death in 1977. (Courtesy Headen Collection at SMSC, College of Southern Maryland.)

ON THE COVER: In 1956, these Boy Scout drummers sold brooms as a fund-raiser on the steps of the second location for the La Plata Post Office on Charles Street. The structure is now the D. H. Steffens Building. It is interesting to note the different sizes of brooms offered in that era. Pictured from left to right are Tommy Walker, Butch Jarboe, Melvin Kersey, Dickie Gee, and Billy Chapman. (Courtesy Headen Collection at SMSC, College of Southern Maryland.)

IMAGES of America
CHARLES COUNTY REVISITED

Jacqueline Zilliox

Copyright © 2009 by Jacqueline Zilliox
ISBN 978-0-7385-6770-9

Published by Arcadia Publishing
Charleston, South Carolina

Printed in the United States of America

Library of Congress Control Number: 2009920706

For all general information contact Arcadia Publishing at:
Telephone 843-853-2070
Fax 843-853-0044
E-mail sales@arcadiapublishing.com
For customer service and orders:
Toll-Free 1-888-313-2665

Visit us on the Internet at www.arcadiapublishing.com

Contents

Acknowledgements		6
Introduction		7
1.	Farms and Villages	9
2.	Events	17
3.	Namesakes	31
4.	Commerce	47
5.	Service Clubs	67
6.	Law and Order	77
7.	Little Las Vegas	99
8.	Infrastructure	107
9.	Local Personalities	115
10.	Recreation	123

Acknowledgments

Because there was so much more to tell, and I did not find the needed photographs at the time, I am happy to do a second book on Charles County after my first. Following the first Charles County book's release, many offered to share their family photographs and provide historically relevant information. I am very humbled by their trust in me. So armed with great material and with the support of Arcadia Publishing, I am glad for the opportunity to pull this continuation together.

As is true with so many old photographs, there were unidentified people and places in them, so I once more called on my oldies but goodies that were able to provide information. I would like to give special recognition to Carl and Bobbie Baldus, Judge Chris Nalley, Joyce Simpson, Whitey Roberts, Phil McDonagh, Gene Raby, Bill Cooke, Buddy Garner, Cheese Jameson, and Storm Hutchinson II. Their love of history is momentous.

There were many individuals native to Charles County who helped me, and without their generosity, this book would not be as good. One such person is Brenda Gee, who aided by editing some of the information.

The Southern Maryland Studies Center, at the College of Southern Maryland, was a major contributor to this work, and I am specifically appreciative of the efficient help of Bonnie White, library assistant. In this book, the studies center is referred to as SMSC.

The Friends of Old Waldorf School also proved helpful by allowing the use of their vintage photograph collection and providing background information on community groups and businesses in Waldorf. I specifically want to recognize Sandy Middleton, Linda Rollins, and Penny Norris.

Last I would like to recognize the diligent assistance from Mary Rice, law librarian at the Circuit Court of Charles County, who provided some of the information on attorneys and judges in the chapter titled "Law and Order."

Introduction

In the first book I wrote about Charles County, I focused on the roots of the county and its communities from the last part of the 19th century until the 1940s. In contrast, this book focuses on the explosive growth the county experienced after World War II until 1970. In 1949, legalized gambling changed the face of this sleepy rural county forever. The proximity of Charles County to Washington, D.C., further increased its appeal to many newcomers. Finally, the commercial and service companies that have taken over the once-pristine farmland have redefined the county as a bedroom community in the 20th century. Life, as locals knew it just 50 years ago, would never be the same.

Still many here will remain and thrive. It has become a land of opportunity for the younger generation. Third and fourth generation entrepreneurs are quite pleased with the level of business. All countians are happy that more tax money is available for better infrastructure, more governmental services are provided, and service clubs for the benefit of the community are numerous, all of which are portrayed in this book in their earliest stages. If you have ever asked who started that, how did things get where they are, or who was that named for, questions like these will be answered in this book.

I would like to leave you with an idea of how far Charles County has come in the last 100 of its 350 years. Car dealerships were not around until the 1920s. Pharmacies were unheard of until the 1930s. Town halls served as movie theaters, and general stores hosted the local post office until the 1940s. The sheriff's department was not an around-the-clock operation, and Route 301 did not exist until the 1950s. Moonshine was a big business until the 1960s. Schools were still segregated until the 1970s.

I will leave you to your pictorial journey and hope you enjoy it as much as I have.

One
Farms and Villages

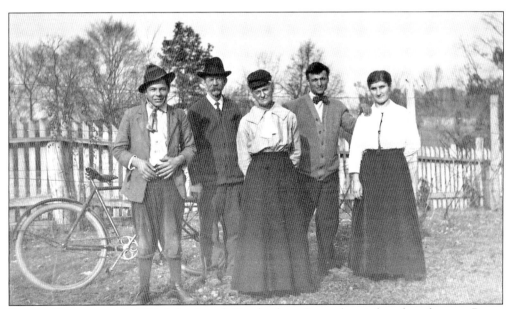

Bender Farmstead. In 1911, John Joseph Bender from Pennsylvania bought a farm on Route 232 in Waldorf due to health reasons. He chiefly grew tobacco but became a self-sufficient farmer by raising everything he needed to sustain his family of five children: John, Albert, Elizabeth, Fred, and Margaret. Pictured in the spring of 1917 from left to right are John Henry; John Joseph; John Joseph's wife, Barbara Susanne; Fred; and Fred's wife, Barbara Bender. (Courtesy Bender Collection.)

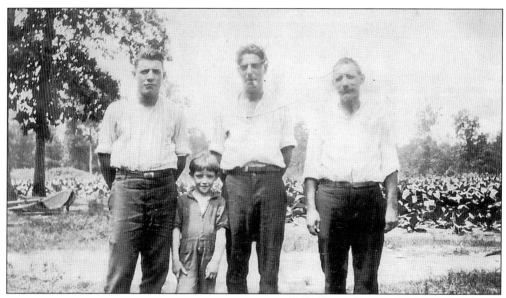

J. E. Bowie Farm and Store. In the 1920s, Joseph Emory Bowie of Ironsides built the combination house and general store he owned with his wife, Edith Mae Maddox Bowie. Joseph was a waterman, farmer, ran a sawmill, and owned sailing vessels that transported goods to and from Maryland ports along the Potomac River to Virginia. He also had one of the first thrasher machines in Charles County and built county roads in the late 1920s. Bowie Road in Ironsides is named after him. Pictured above at the farm from left to right are his son Emory Lee "Smith" Bowie, son William Louis "Willie" Bowie, son Henry Joseph Bowie, and Joseph Emory Bowie. Pictured at left are Joseph Emory's daughter Mary Elizabeth Bowie and his son Willie Bowie in front of the J. E. Bowie General Store. (Both, courtesy Olive Bowie Perry Collection.)

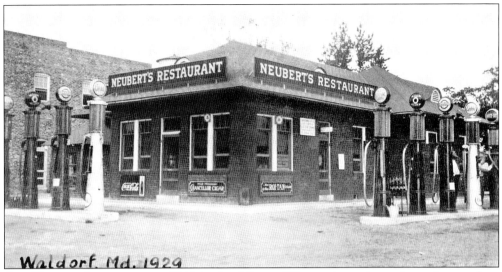

OLD WALDORF INTERSECTION. Old Maryland Route 925 was the main road running north to south until Route 301 was built in 1950. The construction of Route 301 coincided with the building of the Harry W. Nice Bridge that connected Southern Maryland to Virginia. In 1925, a German restaurant, Neubert's, occupied the intersection of Route 925 and Route 5. Gas brands sold there included Sinclair, White Circle, Standard, and Esso. (Courtesy SMSC at the College of Southern Maryland.)

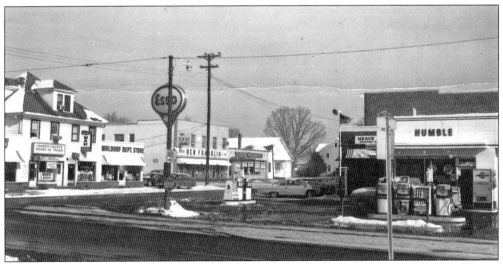

WALDORF INTERSECTION NORTHBOUND. Even though businesses in Waldorf relocated to the newly built Route 301, commerce in 1965 was still heavy at the Route 925 and Route 5 intersection. The Humble, a gas station, replaced Neubert's Restaurant. The white building to the left, previously the Carlton Hotel, held several businesses. To the right of the hotel are the Waldorf Department Store, the Ben Franklin, A&P grocery store, and Piney Church Episcopal Hall. (Courtesy Friends of Old Waldorf School.)

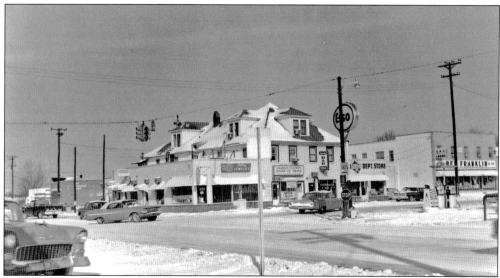

WALDORF INTERSECTION WESTBOUND. During the 1940's the old Carlton Hotel became a commercial center and housed Dr. Rosenstein's Pharmacy and Drugstore, Talley Jewelry, and a ladies' clothing store, the Smart Shoppe. By 1965 they had all moved to the Howard Building across the street. The Fitzgerald and Fitzpatrick Bar was in the building at the time of this 1965 photograph which had replaced Booger Johnson's Bar. Pictured to the left of the white commercial building, formerly the Carlton Hotel, is the second location of the Waldorf Bank. (Courtesy Friends of Old Waldorf School.)

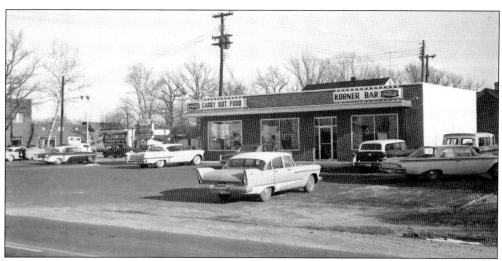

WALDORF INTERSECTION SOUTHBOUND. The Korner Bar was the previous location of Hamilton and Gates Restaurant. When Guy Berry bought it, he tore down the old house and constructed the new building that is still there. Across Route 5 on the left was Fowler's Plumbing and Heating Supplies, originally Holmes Plumbing, a heating and electrical supply company. (Courtesy Friends of Old Waldorf School.)

COOKSEY FARM IN DENTSVILLE. Harold Roger Cooksey owned Cooksey's Store as well as approximately 20–25 acres on both sides of Route 6 in Dentsville, where he mainly grew tobacco. His six children, Harold Roger Jr., Bonnie Lynn, Robert, Barbara, Brenda, and Betsy, grew up working on the farm or in the store. From left to right are Harold Roger Jr., Robert, and Bonnie Lynn. On the far right is Oscar Dorsey, a tenant laborer. (Courtesy Cooksey family.)

WORLD WAR II GERMAN LABORERS. During the war, the minimum wage jumped from $2 an hour to $5, making affordable labor difficult to find. Maryland farmers requested help from the state that came in the form of a Farm Emergency Labor Program. Part of that program was to procure German prisoners of war as laborers. A daily record of German prisoners used on J. G. Cooksey's farm in Dentsville is pictured. (Courtesy Cooksey family.)

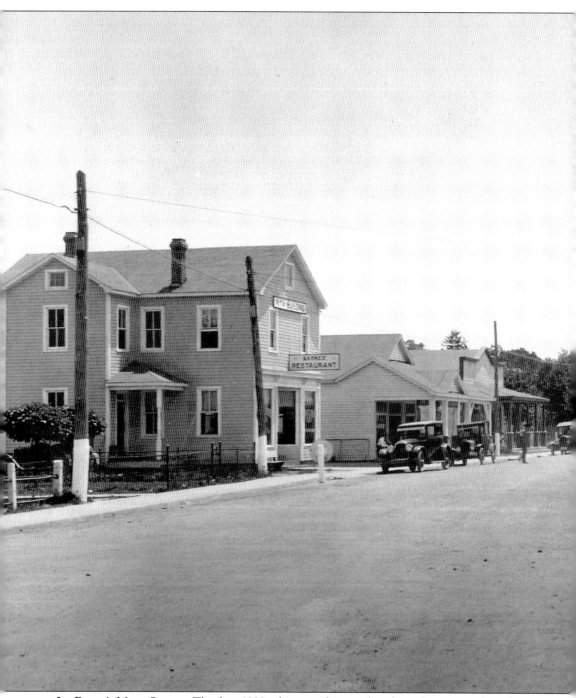

La Plata's Main Street. This late-1920s photograph was taken from the corner of Washington Avenue and Charles Street looking east toward the railroad tracks. Pictured from left to right are the Barnes Restaurant that became the Stumble Inn, Mitchell's Hardware Store that became the Franklin Winkler Hardware Store, Lyon and Nalley Store, and T. R. Farrall Store. Across Charles Street and continuing from left to right are the Bowie Lunch Room and Ice Cream Parlor, Eastern Shore Trust County Bank that became the County Trust Bank, Hyde Printing,

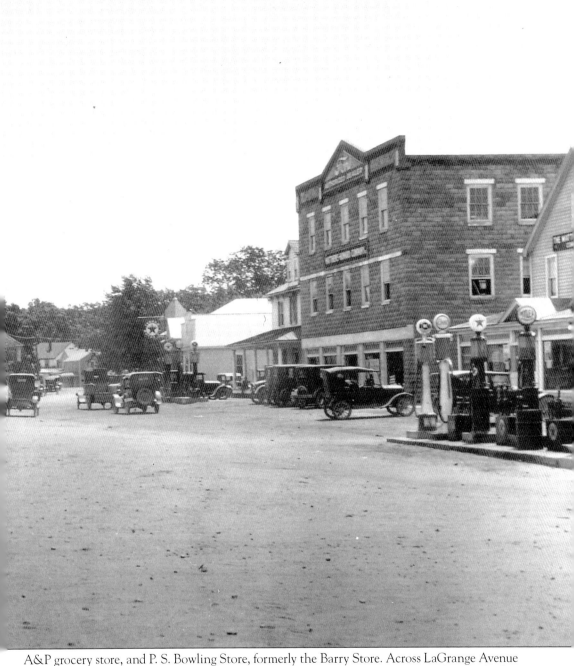

A&P grocery store, and P. S. Bowling Store, formerly the Barry Store. Across LaGrange Avenue is the W. J. Mitchell Building, where the first post office was; the Matthews-Howard car dealership with the car lot on the third floor reached by elevator; and a wood frame Matthews-Howard Building, which became Shorty's Restaurant. The gas pumps on the far right belong to Central Garage, now known as Martin's Garage, a third-generation ownership. (Courtesy Maryland State Archives, Merrick Photograph Collection.)

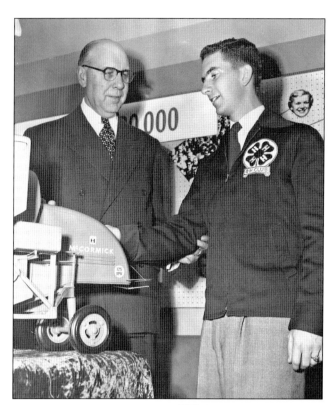

4-H NATIONAL RECOGNITION. In November 1951, Carl Baldus received a national award for his field crop production. It was also the first year he planted at his new home, Salem, located in Spring Hill. He received a scholarship of $500 for education at the University of Maryland, where he studied agriculture. Pictured from left to right are John L. McCaffrey, president of the International Harvester Company, and Carl Baldus. (Courtesy Baldus Collection.)

WHITE HOUSE CEREMONY. In March 1952, Carl Baldus was chosen by the State Boys 4-H Club of America to represent them in conferring to Pres. Harry S. Truman a recently published history of 4-H club work. This photograph was taken in front of the White House. Pictured from left to right are Carl Baldus, President Truman, and representing 4-H club girls, Elizabeth Mason of Virginia. (Courtesy Baldus Collection.)

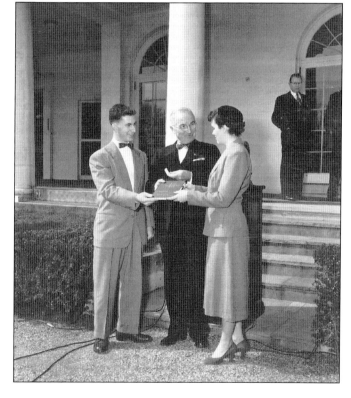

Two

EVENTS

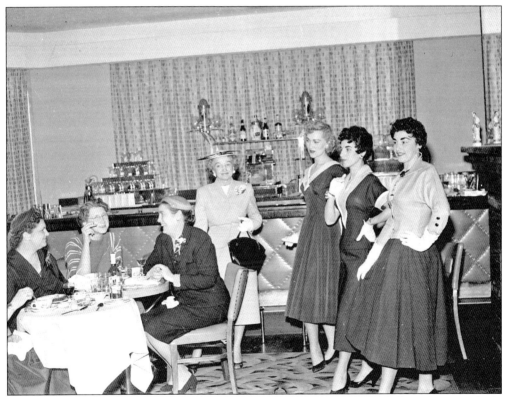

FASHION SHOW IN LA PLATA. In the 1950s, Mable James owned her own dress shop in a little building next to the Stumble Inn on Charles Street in La Plata. Pictured at a fashion show at the Open Hearth Restaurant from left to right are Betty Hogge, Lorena Bowling Simms, Margaret Brown, Mable James, and three unidentified models on the right. (Courtesy Headen Collection at SMSC, College of Southern Maryland.)

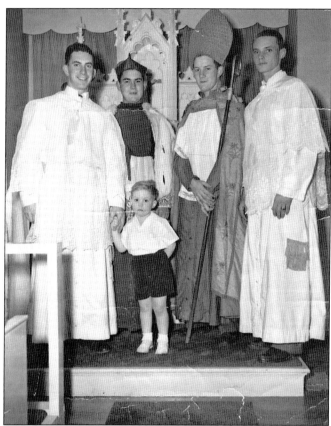

SACRED HEART CHRISTMAS PAGEANT. The Catholic church on St. Mary's Avenue in La Plata presented a costumed Christmas Pageant in 1948 that featured young parishioners under the watchful eye of Fr. William H. Powell. Pictured from left to right are Carl Baldus, Tommy Jameson, Pete Barbour, and Ed Sanders, and the little boy is Dickie Mudd. (Courtesy Baldus Collection.)

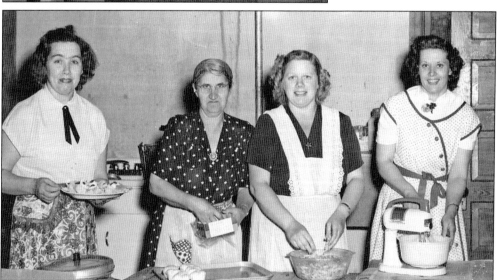

ST. MARY'S CHURCH DINNER. St. Mary's Church of Bryantown was well known for their tasty church dinners in the 1950s. When people sat down, young ladies brought their drink, a family-style meal in big bowls refilled frequently, and then dessert was served. Pictured preparing a meal from left to right are Ethel Wheatley, Barbara Bender, Irma Jameson, and Mary "Ceal" Jameson. (Courtesy Bender Collection.)

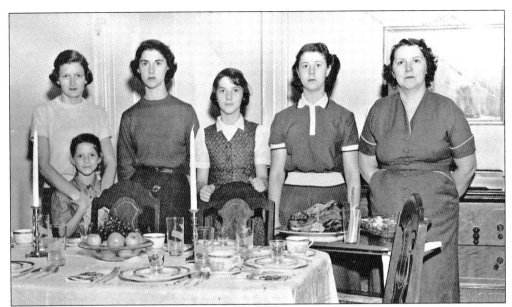

THANKSGIVING DINNER, 1948. Benjamin Franklin Sr. and Mary Elizabeth Bowie of Oakland Farm in Welcome loved to gather family and friends in their home for the holidays. Their Southern Maryland Thanksgiving feast included ham, turkey, corn pudding, sweet potatoes, watercress, potato salad, and pumpkin pie. Pictured from left to right are guest Margaret Green, Mary Edith "Sally" (child in front of Margaret), Joyce Elizabeth, Judith Maureen, Olive Belle, and Mary Elizabeth Bowie. (Courtesy Olive Bowie Perry Collection.)

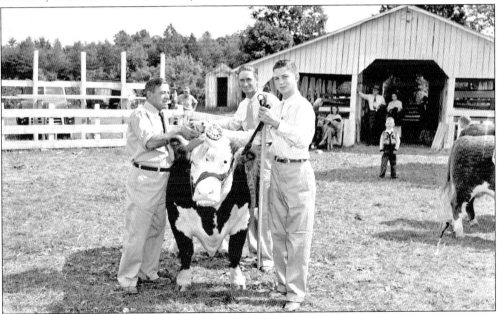

CHARLES COUNTY FAIR, 1953. The fair was first organized by volunteers in 1924 and held at Chapel Point Park. In 1925, the 40 acres the fairgrounds currently occupies, located in Spring Hill just off Route 301, were purchased by the county. Pictured from left to right by the grand champion Hereford steer in 1953 are Scotty Blackhall, J. Elwood Cusic, and holding the reins, Joe Cusic. (Courtesy Headen Collection at SMSC, College of Southern Maryland.)

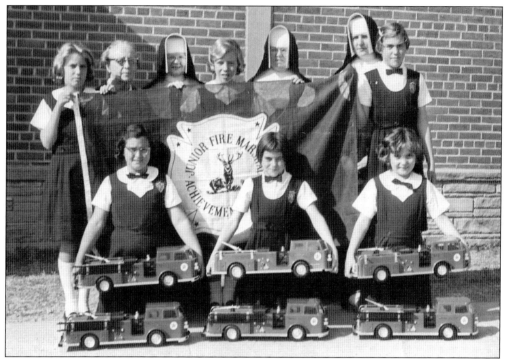

FIRE PREVENTION CONTEST. In 1963, the La Plata Volunteer Fire Department junior fire marshal contest was held for fourth through sixth graders of Archbishop Neale and Port Tobacco Schools. Southern Maryland Oil donated toy Texaco fire trucks. Archbishop Neale School winners are pictured, from left to right, (first row) Julian Posey, Brenda Cooksey, and Theresa Martin; (second row) Cherry Mitchell, Sally Cruikshank, and Barbara Cooksey; (third row) Mrs. McGinnis, Sister St. Anne, principal Sister Isidore, and Sister Mary Thomas. (Courtesy Cooksey family.)

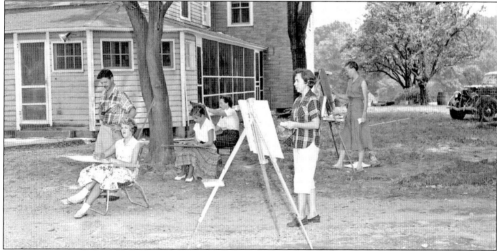

FINE ARTS EXHIBIT AT FAIR. In 1954, the Charles County Fair Board approved the addition of a new department for fine art exhibitors. In preparation for the new classification, Washington, D.C., artist and teacher Ralph deBurgos gave the art class pictured above in the fall of 1953. DeBurgos also arranged the exhibit for the fair. The artists in the photograph are unidentified. (Courtesy Headen Collection at SMSC, College of Southern Maryland.)

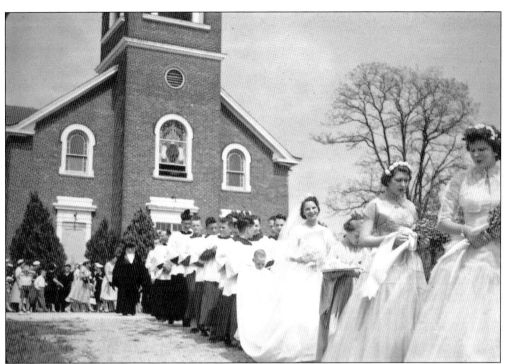

NOTRE DAME'S MAY PROCESSION. The Notre Dame School was a Catholic school started by St. Mary's Parish of Bryantown. In May, one senior girl was chosen by her classmates to place a wreath of flowers on a statue of the Virgin Mary. All 12 grades were present during the processional walk from the school to the statue that took place on a Sunday. In the front of the senior court were 50 or so classmates dressed in uniform, and behind the court were altar boys and priests. The girl chosen to crown the Virgin Mary with a fresh flower wreath in 1956 was Susie Bender. Pictured above in white dress and veil, the last girl of three, Susie was attended by fellow senior classmates wearing pastel dresses. In front of her is Helen Marie Jameson, and in front of Helen is Catherine Vennemann. (Both, courtesy Bender Collection.)

PRIVATE KINDERGARTEN CLASS. Public schools in Charles County did not start kindergarten classes until 1972. Prior to that, women who had a teaching degree taught private kindergarten classes. Billy Gee is pictured at left standing on the homemade podium at Irma Wheeler's kindergarten class graduation of 1956. It was a circus theme, and Billy was the ringmaster. Pictured below are his fellow classmates, from left to right, (first row) Steve Elder, Randy Martin, Jean Pearson, Billy Gee, Larry Pearson, Bobby Mills, and Bernie Posey; (second row) Clara Wooddy, Christy Wheeler, Wayne Tucker, Sharon Turner, Donald Tabler, Brandon Jones, and Louis Hindle; (third row) Pat Nalley, Phyllis Frere, Susie Gamble, Jamie Ferris, Karen Elder, and Tommy Carrico. (Both, courtesy Gee Collection.)

300TH ANNIVERSARY LIGHTING CEREMONY. The first part of Charles County's 300th birthday festivities of 1958 included illuminating a 25-foot-high fabricated cake on Highway 301 in Waldorf just south of the Prince George's County line. The county's only known centenarian at the time, Delcena Jordan of Marbury had the privilege of flipping the switch that illuminated the cake. The event was marked by an invocation by Rev. Marc A. Nocerino of Port Tobacco Parish. Afterwards there were fireworks, and local Ben Mitchell Morris sang the "Star Spangled Banner" to 1,000 attendees. Pictured below are P. Reed McDonagh, of the advertising sub-committee for the Charles County Tercentenary Committee, and his two daughters, Theresa and Janice. (Right, courtesy Headen Collection at SMSC, College of Southern Maryland; below, courtesy McDonagh Collection.)

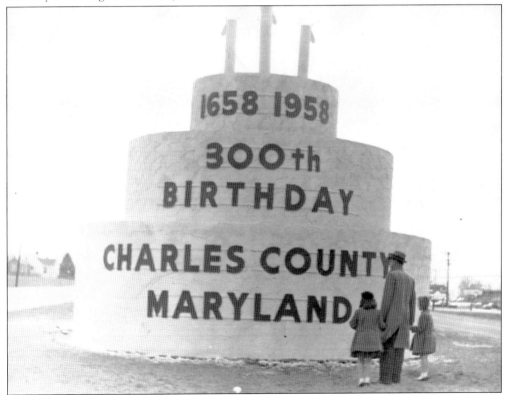

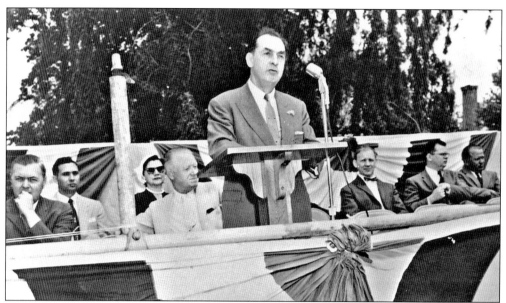

PORT TOBACCO WELL HOUSE DEDICATION. In the summer of 1958, when Charles County turned 300, the restored brick well house that sits in front of the reconstructed Port Tobacco Courthouse was given proper prominence. Pictured from left to right are Judge J. Dudley Digges; John T. Parran Jr.; Ann Mudd; Col. Frank B. Wade; Dr. Thomas G. Pullen Jr., speaker; Dr. Arthur Wooddy; George J. Quinn, builder; and Frederick Tilp, architect. (Courtesy Wade Collection.)

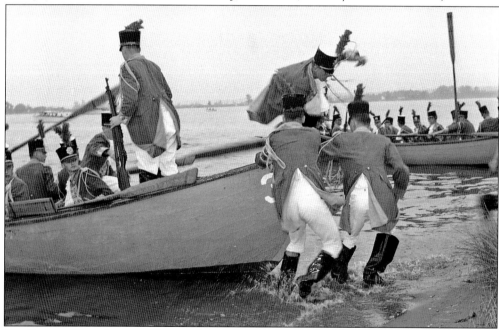

THE BRITISH HAVE LANDED. During the tercentenary celebration in Charles County, reenactors landed two longboats onto the shores of Benedict, the site of the 1814 invasion. After that historic landing, the British marched into Washington on the pretense of chasing the Chesapeake Flotillamen who had engaged them in battle on St. Leonard Creek on the Patuxent River. (Courtesy Headen Collection at SMSC, College of Southern Maryland.)

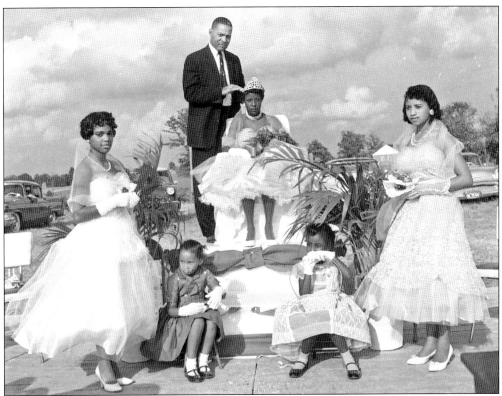

POMONKEY FAIR QUEEN. In 1959, Elaine Cooper was crowned queen of the 12th annual Charles County Farmer's Association Fair held at the Pomonkey Fair Grounds. Pictured crowning the queen is Dr. F. H. Harris, dean of men at Maryland State College. Cooper's younger attendants seated from left to right are Valerie Butler and Jo Ann Chesley. Standing from left to right are Margaret Davis and Peggy Butler. (Courtesy Headen Collection at SMSC, College of Southern Maryland.)

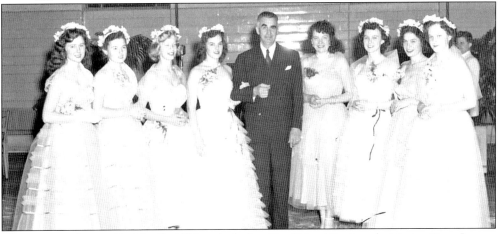

LEATHERNECK QUEEN. On May 20, 1956, at the Indian Head Naval Station, the Marine Corps League of Maryland crowned Helen Cotrufo of Potomac Heights their convention's queen. Pictured with Lt. Gen. Pedro DelValie (retired USMC) from left to right is Helen's court: Barbara Bardroff, Joan Joonson, Margaret Groenwaldt, Helen Cotrufo, Kitty Woodsome, Mary Ann Jones, Sylvia Coltier, and Nancy Mattingly. (Courtesy Headen Collection at SMSC, College of Southern Maryland.)

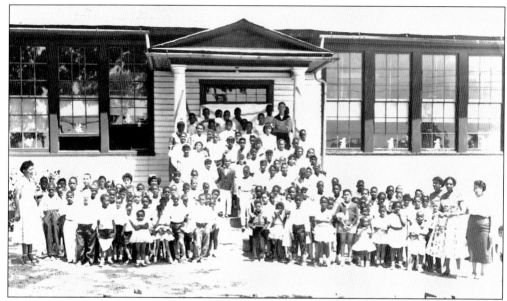

WALDORF AFRICAN AMERICAN SCHOOL. In the 1950s, African Americans attended a segregated three-room schoolhouse on Route 5 for grades one through seven. Pictured above is the entire school body posing on the steps of the schoolhouse before wrapping the Maypole. The teacher in the foreground on the far left is Beverly Carwell. The teachers on the far right, from left to right, are Pocahontas Catrell, Ruby Green, and Florence Butler. After graduating from the seventh grade, the children went to Pomonkey High School. Pictured below is J. C. Parks, the first African American superintendent of schools in Charles County, crowning the king and queen of May Day in 1955. The king was Michael Webb, and his queen and friend was Sandra Penny. The court seated around them from left to right are Roy Farrar, unidentified, Ann Hawkins, Ernest Bowman, Vera Duckett, Carlos Proctor, Cachita Farrar, and Jerome Heard. (Both, courtesy Sandra Penny.)

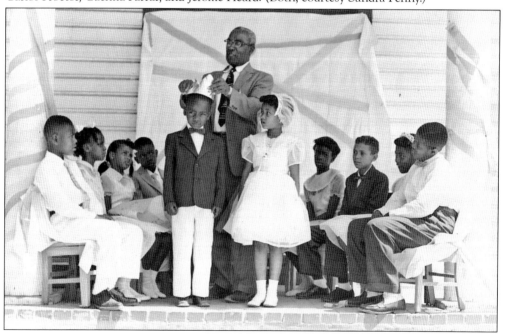

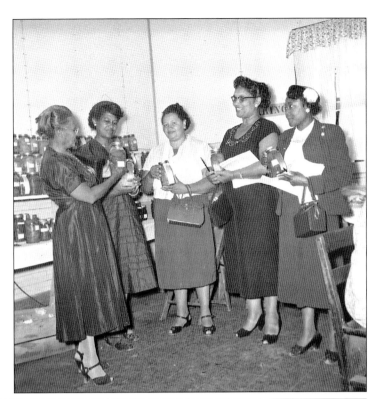

FARMERS ASSOCIATION FAIR PRIZE WINNERS. In 1956, these five homemakers won prizes for their preserves at the Farmers Association Fair held at Pomfret. This fair was the segregated version of the Charles County Fair. Pictured from left to right are Naomi Turner Middletown, demonstration agent; Lillian Butler; Mrs. Martin Butler; Margaret Hungeford; and Mrs. Luther Stuckey. (Courtesy Headen Collection at SMSC, College of Southern Maryland.)

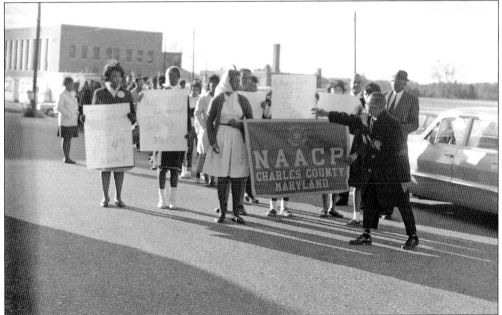

LOCAL NAACP RALLY. In 1921, Luther Stuckey started the Charles County branch of the National Association for the Advancement of Colored People. The group began a ploy of having a twosome, one Caucasian and the other African American, go into a business and attempt to get equal service. If they did not, the business would be picketed. This march ended at the courthouse in peaceful protest. (Courtesy Headen Collection at SMSC, College of Southern Maryland.)

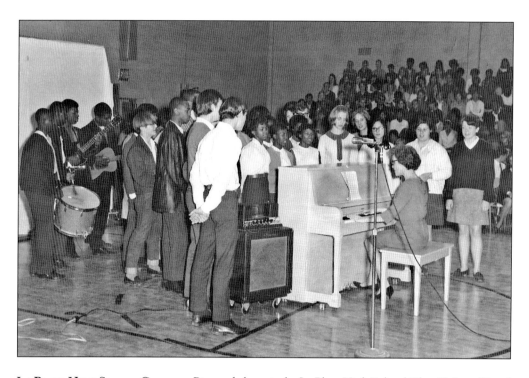

LA PLATA HIGH SCHOOL CONCERT. Pictured above is the La Plata High School Glee Club and Band in 1964. They are performing in the old La Plata High School auditorium under the leadership of music director Dottie Gee, seated at the piano. Gee began teaching in Charles County in 1947 at Glasva Elementary School. In 1950, she became director of La Plata High School's music department until 1969, when she became music teacher at Walter J. Mitchell Elementary School, a position she retired from. Pictured below is the Silver Bell Serenade, a Christmas program. Each program was filled with every chorale and music group the school had. The spring program was another special program the high school put on every year. (Both, courtesy Gee Collection.)

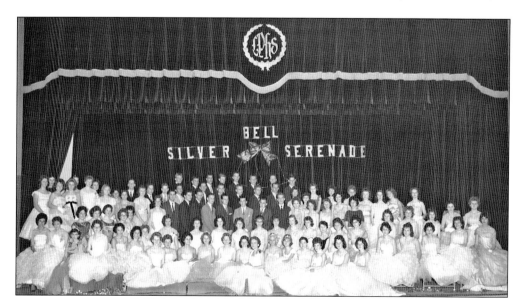

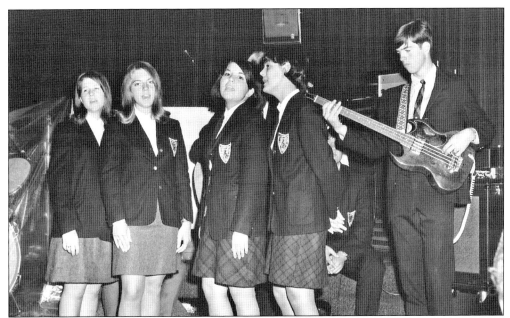

LA PLATA GLEE CLUB PERFORMS. This smaller group usually sang an alternative style of songs and was part of music director Dottie Gee's singing group called the Terpsichore Singers. They played in local establishments and at Walter Reed Army Hospital. Pictured are members of the La Plata High School Glee Club of 1968, from left to right, Beryl Davis, Mary Ann Sullivan, Kay Perry, Linda Sweeney, and Billy Gee, performing on base guitar. (Courtesy Gee Collection.)

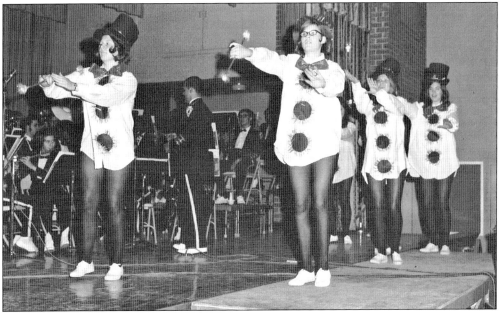

LA PLATA HIGH SCHOOL CHRISTMAS CONCERT. In 1969, the stage in the high school's auditorium was set up for these snow women to perform a majorette routine to the Christmas song, "Frosty the Snowman." Pictured leading the band is director Ronald Braithwaite. Performers from left to right are Bonnie Brown; Betsy Cooksey; Brenda Cooksey, partially obscured; Cheryl Cox; and Barbara Cooksey. (Courtesy Cooksey family.)

FASHION SHOW FOLLIES. There was a lot of folly during the intermission of a fashion show held in 1964 at the Hawthorne Country Club in La Plata. The P. S. Bowling Company, a fine clothing store located on Charles Street in La Plata, sponsored the show. To accentuate the store's progressive styles, the three in the photograph modeled old-fashioned attire. Pictured from left to right are James Mudd, store owner; Bobbie Baldus; and Page Clagett. (Courtesy Baldus Collection.)

Three

NAMESAKES

DR. THOMAS L. HIGDON. Dr. Higdon lived at Wayside from 1898 until 1957. He traveled by horseback or horse and buggy until purchasing his first car in 1914. Higdon and his wife, Ella, worked toward consolidating the first private Charles County high school in 1924. He served as president and vice president of the school board. The Dr. Thomas L. Higdon Elementary School opened in Newburg in 1989. (Courtesy Higdon family.)

THOMAS PATRICK MCDONAGH CHEVY DEALERSHIP. Prior to establishing a Chevrolet dealership in La Plata in 1923, McDonagh was a drummer (salesman) for the Maryland Biscuit Company. While in Charles County he met his future wife, Theresa Olivia Wills, while staying at the Wills Hotel in Bel Alton. In 1923, McDonagh was among the first to sell automobiles in the county from colorful brochures, and then in 1928 he constructed his car dealership on Washington Avenue. He went on to become the first fire chief for the La Plata Volunteer Fire Department, was post commander of American Legion Harry White Wilmer Post 82, and served as grand knight of the Neale Council Knights of Columbus. Pictured above is Thomas McDonagh at his dealership desk. Pictured below, second from the left (between the gas pumps), is Thomas McDonagh, others unidentified, in front of McDonagh Chevrolet. (Both, courtesy McDonagh Collection.)

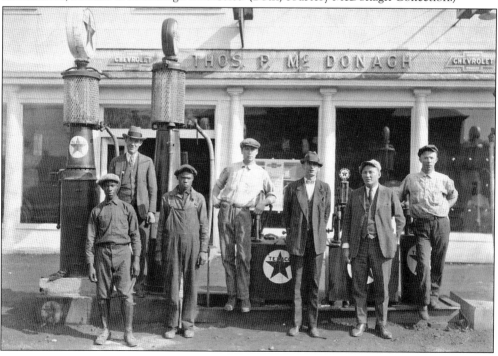

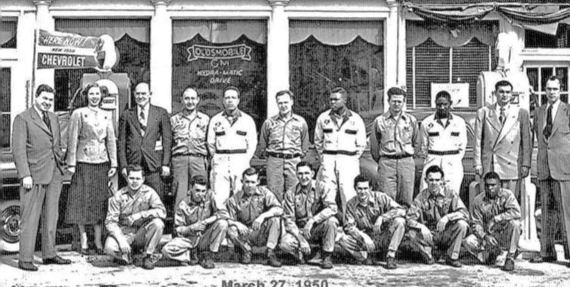

McDonagh Family Business. After being in business for 25 years, Thomas Patrick McDonagh handed over the reins of his automobile dealership to son Reed. In the early 1960s, Gov. Millard Tawes appointed Reed magistrate judge for Charles County. During this time, the family automobile dealership was transferred to Carroll Barnes and relocated to the corner of U.S. 301, where it operated for many years. Reed also helped to establish and became the first president of the Charles County Chamber of Commerce in 1957 and was chairman of the Red Cross. Pictured is the McDonagh dealership staff in 1950. From left to right are (first row) Carlton Wedding, unidentified, Gerry Clements, Bob Simpson, Noble Bowie, Bobbie Clements, and Raymond Wallace; (second row) unidentified, Theresa McDonagh (daughter of Thomas), Thomas Patrick McDonagh, Manual Compton, Charles Brisco, Ed Moyer, Horace Wallace, unidentified, George Muschette, Bobbie Simpson, and Reed McDonagh (son of Thomas). (Courtesy McDonagh Collection.)

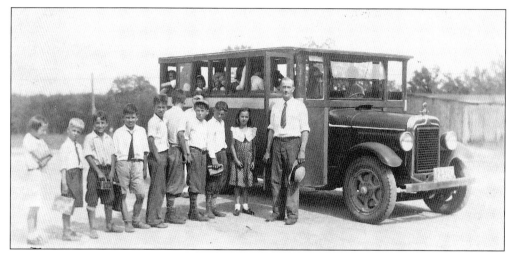

KELLER BUS SERVICE. In the mid-1920s, Charles County school superintendent Gwyn asked Ernest Keller if he would be interested in purchasing a bus in order to work as a bus driver for the school system. Initially Keller declined, but he started driving for them in 1927. He picked up children in the Hughesville/Gallant Green area and St. Mary's School in Bryantown. When he retired in 1967, he owned nine buses. The company currently owns over 100 school buses as well as commuter and charter buses. School bus drivers must attend mandatory safety training class a few times a year. Pictured above on the far right is Ernest Keller picking up children at the Hughesville School. Pictured below is a school bus driver safety training class taught by Warren H. Deyermond, supervisor of transportation for the Charles County School System in 1964. (Both, courtesy Ed Keller.)

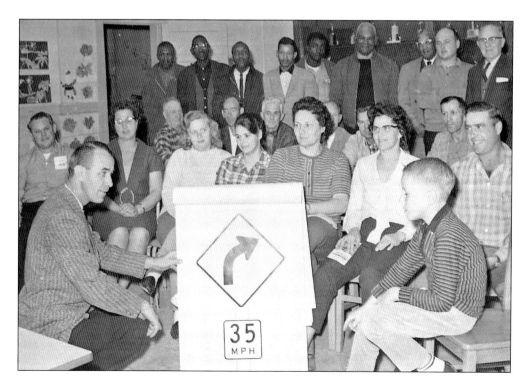

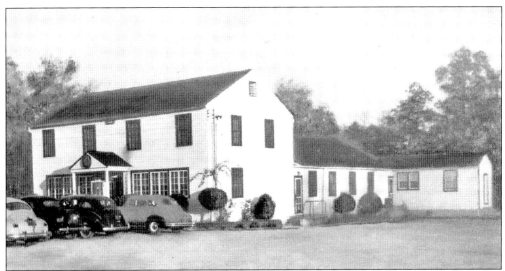

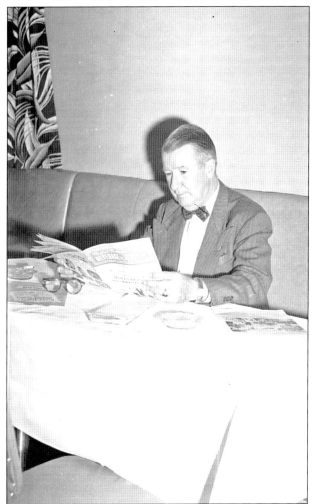

WALDORF RESTAURATEUR BERNIE JARBOE. Bernie Jarboe was owner and manager of one of the classiest restaurants in Waldorf from the 1930s through 1950s. His first inn and restaurant was located on Route 925 near Davis Antenna. The restaurant offered dancing on Friday and Saturday nights. Hotel accommodations were also available. Their popular dinner item was fried chicken Southern Maryland–style. People traveled from Annapolis and Washington to patronize his establishment. When Route 301 was built, he relocated there on the opposite corner of the present-day Ken Dixon Automotive. He also served six terms as president of the Maryland State Licensed Beverage Association. By 1953–1954, the first location of the Bernie Jarboe Inn became the North Inn, which featured some of the finest music and singing in the area. Bernie Jarboe's first location is pictured above. Pictured at right is Bernie Jarboe seated in his new restaurant. (Above, courtesy Dottie Crecelius; right, courtesy Headen Collection at SMSC, College of Southern Maryland.)

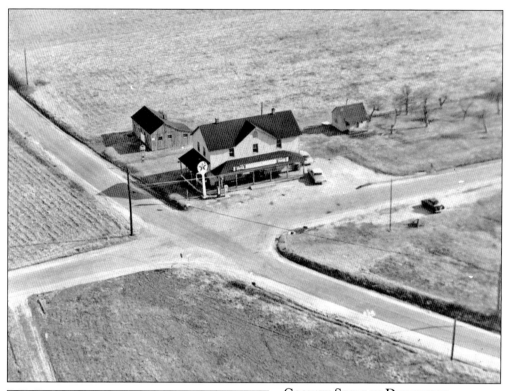

COOKSEY STORE IN DENTSVILLE. James Glover Cooksey opened the Cooksey Store located in Dentsville in 1906. William Elmer Cooksey took it over in the 1950s. His son, Harold Roger Cooksey, sold it to Melvin Bridgett in the early 1990s. It is still in operation as a general store today. Initially dry goods were purchased for the store by a weekly trip to Baltimore, while local Amish provided eggs. They also sold buggies. (Courtesy Cooksey family.)

AMY LEE COOKSEY. Before "Miss Amy" married Elmer Cooksey, her third cousin, in 1920, she taught in a one-room schoolhouse on the corner of Trinity Church Road and Route Six in Dentsville. Prior to moving to Dentsville, she grew up with her family in Mount Victoria. She is famously remembered for making the family's favorite dessert, pineapple upside-down cake, on a wood stove. (Courtesy Cooksey family.)

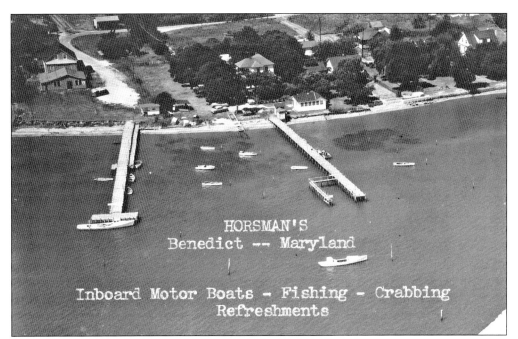

HORSMAN'S RESTAURANT, BENEDICT. The Horsman family has been in Benedict since the 1840s, with its members being watermen, boat builders, and entrepreneurs. As a waterman, George would harvest seafood from the Patuxent River, and his wife, Nettie, would sell it in Baltimore or Washington. In the 1950s, George built motorboats and rented them for $5 a day. Business was good and the Horsman's opened a small restaurant in 1952. Pictured at right are George T. Horsman Sr. and his wife, Nettie Howard Shorter Horsman. The Horsman dock is pictured above on the right and the small white building to the right of the dock became their restaurant. Horsman's large oyster boat, *Millie*, can be seen in the right foreground. The large white house behind the restaurant was their home that arrived as a kit by barge in 1922. (Both, courtesy George Howard Post and Judy Ann Post.)

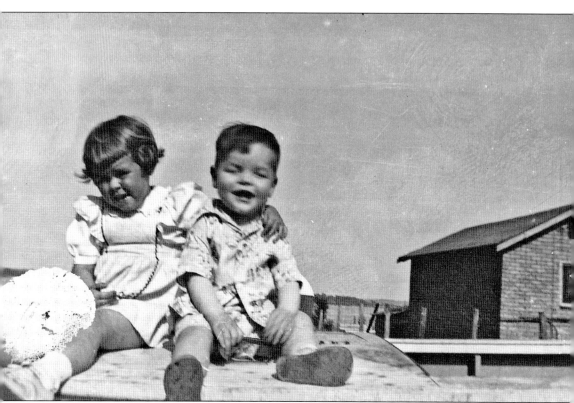

LIFE IN BENEDICT. George Howard Post and Judy Ann Post sit on top of an upturned rowboat built by their grandfather, George T. Horsman Sr., in 1951. Each participated in the family businesses. George helped his grandfather build boats and handle the boat rental customers, while Judy helped in the Horsman Restaurant's kitchen and waited on tables. (Courtesy George Howard Post and Judy Ann Post.)

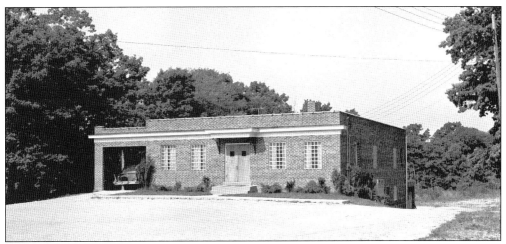

AREHART-ECHOLS FUNERAL HOME. Garyton C. Echols Jr. and his wife, Carol, purchased Arehart Funeral Home in 1969 from Roy C. Arehart, who established the funeral home in 1954. Garyton joined the firm in 1957 after branching out from his grandfather's establishment, the Chambers Funeral Homes, in Washington and Maryland. His sons Grayton C. Echols III and David C. Echols now run Arehart-Echols Funeral Home with their father. (Courtesy Headen Collection at SMSC, College of Southern Maryland.)

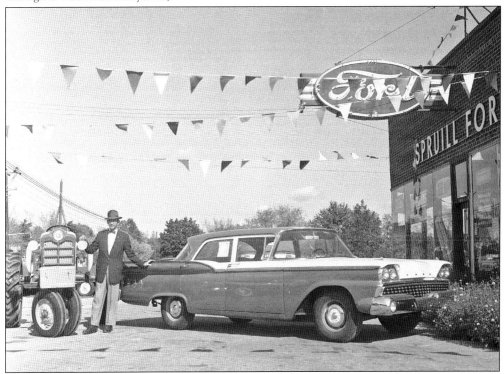

SPRUILL FORD IN WALDORF. William and Doris Spruill, who purchased it from Gwynn and Jameson, owned the dealership in the late 1940s. At the time they were the only Ford dealership in Waldorf, and they sold farm tractors and automobiles. The building is located on Route 925 and is now Waldorf Tire. William Spruill is pictured in front of his dealership. (Courtesy Headen Collection at SMSC, College of Southern Maryland.)

Parsons Hall. Woodrow "Woodie" and Lena Parsons came to Waldorf in the late 1940s from Baltimore, where they owned a transfer trucking company. They bought the Waldorf Recreation Center that consisted of a bowling alley and bar. After a fire in the early 1950s, they rebuilt and changed the business into a dance and social hall and later a skating rink. Pictured at left are Woodrow and Lena Parsons in front of their business on Old Washington Road. Behind them on the left is the Waldorf Upholstery Shop and on the right is the first Sherwood Forest Restaurant location. Skaters in the hall during the 1950s are pictured below. From left to right are Patty Ambrose, Martha Bateman, Ethyleen Pennock, unidentified, Johnny Kinsey, Thomas Bateman, and two unidentified. (Left, courtesy Roberts Collection; below, courtesy Headen Collection at SMSC, College of Southern Maryland.)

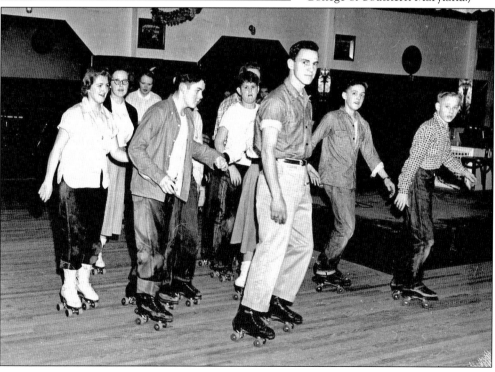

Harry Cosmos and Glisterine Penny. Harry, one of 10 children born to the Penny family of Myrtle Grove, was known to all as Pat. He got that nickname by being born on St. Patrick's Day. He and his wife, Glisterine, or "GeeGee," were successful entrepreneurs in Southern Maryland who began with the Southern Maryland Music Company, which leased jukeboxes to establishments from southern Prince George's County to St. Mary's County. Prior to that, Pat was an authorized bail bondsman and a Washington cab driver. That is how he met his wife, GeeGee, a transplant from Lebanon, Tennessee. Pat's first establishment, Pat's Tavern, opened in 1951 on Route 925. The tavern offered African Americans musical entertainment and slot machines. Pictured below are Pat and GeeGee's first daughter, Sandra, in her friend Michael Webb's front yard. Pat's Tavern is behind them. (Both, courtesy Sandra Penny.)

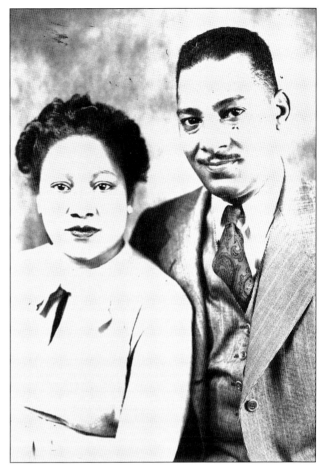

PAT AND GEEGEE'S TAVERN. After opening their first leased business, Pat's Tavern, Pat and GeeGee bought property on Route 925 in the mid-1950s and opened their second restaurant and tavern. The restaurant featured rotisseries where Penny perfected his famous barbecue technique and sauce. His family continues his legacy with a barbecue catering business. The building is now home to American Legion 293. Pictured above in front of Pat and GeeGee's Tavern are, from left to right, Vickie Penny, Wanda West, Gino Eastep, Louis Mason, and baby Patsy Penny. Pat and GeeGee also rented space to a hair salon and barbershop in the building. Pictured below at a table in the tavern, from left to right, are Louann Collins, whose husband worked for the Penny Company; Grace Hill, the first African American hairdresser in Waldorf; little Patsy Penny; Agnes Prather, GeeGee's sister; Audrey Marshall; and GeeGee Penny. (Both, courtesy Sandra Penny.)

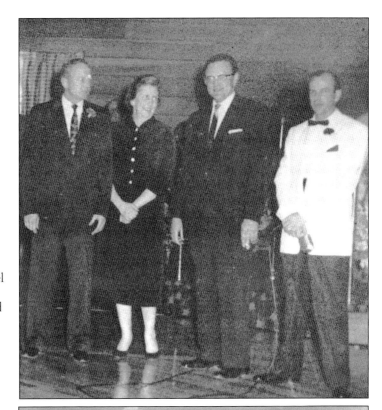

CHANEY ENTERPRISES. Eugene "Babe" Chaney Sr. began his gravel company in Prince George's County before coming to Charles County in the 1940s when work on the new Crain Highway began. In 1962, Babe Chaney started the Charles County Sand and Gravel Company. Later that year, he and son Richard "Dickey" Chaney founded the Charles County Concrete Company. Pictured above at the grand opening of the Waldorf Restaurant's Loft Room, built and owned by Chaney, from left to right are Babe Chaney; his wife, Grace; Bill Beard; and bandleader Frank Vieohl. Pictured below at the Charles County Sand and Gravel location on Acton Lane in Waldorf are, from left to right, unidentified; Dickie Chaney, then president of Charles County Sand and Gravel; and Jack Havenner, then vice president of Charles County Sand and Gravel. (Above, courtesy Whitey Roberts; below, courtesy Chaney Enterprises.)

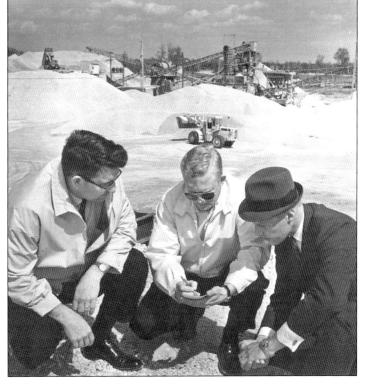

CHANEY BUSINESS. In 1967, Dickey Chaney and his younger brother Francis H. Chaney II took the reins of the company started by their father, Babe Chaney. Pictured in the 1960s at the Waldorf Restaurant's Loft Room are, from left to right, Whitey Roberts, wife Daphene, Jack Havenner, Eugene Chaney Jr., wife Brenda, Dickey Chaney, wife Mary Mac, George Henning, and wife Jackie. (Courtesy Roberts Collection.)

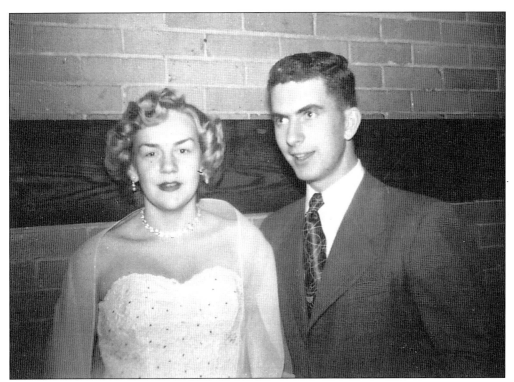

BALDUS REAL ESTATE. Carl and Bobbie Baldus were married in 1953 and promptly started their appraising and farm management business from an in-home office. They moved into their first location at 101 Charles Street in La Plata in March 1971, but the tornado of 2002 destroyed the building. Their new real estate office and commercial building, Baldus Centre, opened in 2004. Pictured above are Carl and Bobbie when they were first married in 1953. The staff when they opened for business in 1971 are pictured at right, from left to right, (first row) Carl Baldus, Bobbie Baldus, and L. K. Farrall, nephew; (second row) Bonnie Baldus Grier, Mary Louise Furbush, and Jean Barbour; (third row) Donnie Cox and Mike Dyer. (Both, courtesy Baldus Collection.)

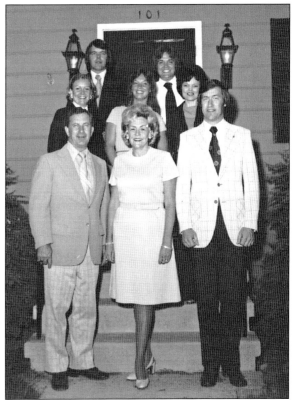

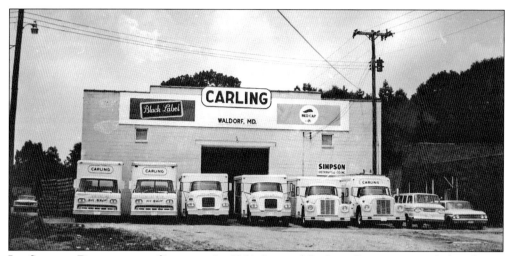

JIM SIMPSON DISTRIBUTING COMPANY. In 1954, Jim and Barbara Simpson started their liquor distribution business in Prince George's County with one brand, Baltimore-brewed Carling Black Label. They moved their family and business to Charles County in 1960. Their first location was a 3,500-square-foot warehouse on Route 925 south. Their second was a 10,000-square-foot warehouse on Route 5 south, and the third was a 17,000-square-foot space in St. Charles that distributed 30 liquor brands to Calvert and St. Mary's Counties. The Simpsons sold their distributorship in 1986. Jim entered local public service life in 1967, finally retiring as senator in 1995. Pictured above is the first Simpson Distributing Company in 1963. Pictured below, from left to right, are Billy Hill, who now owns St. Mary's Landing Restaurant; Neal Gatton; John Gatton; Jim Simpson; Lathan Gragan; and Freddy Jewell. (Both, courtesy Simpson Collection.)

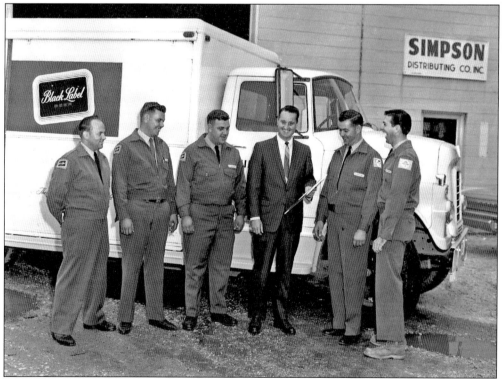

Four

COMMERCE

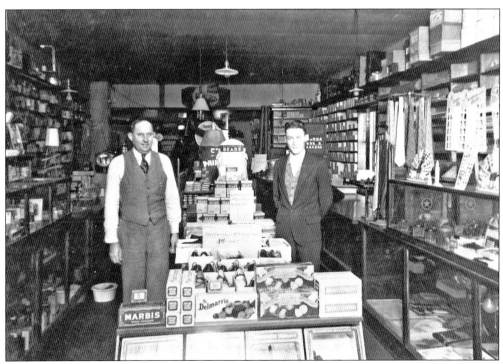

LYON AND NALLEY GENERAL STORE. W. Robert Nalley and Harold W. Lyon owned and ran the store located on Charles Street in La Plata from 1930 to 1961. Originally the store had no refrigeration, and during the 1950s, they offered quality meats such as sirloin steak for 89¢ a pound or a canned ham for $4.49. The store was where El Dorado Restaurant is now. (Courtesy Nalley Collection.)

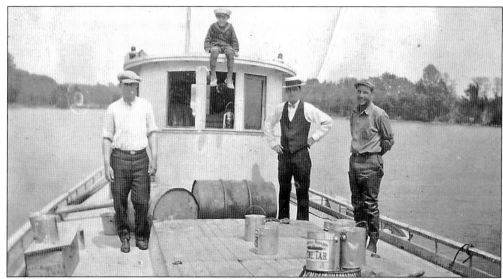

SHIPPING ON THE POTOMAC. Joseph Emory of Ironsides owned the *Mary BS*, named after his daughter, Mary Elizabeth, and his first mate's daughter, Mary Skinner. The ship was used to transport imports and exports from port towns like Alexandria or Fairfax to local ports at Brentland and Nanjemoy. Pictured from left to right are Joseph Emory's sons, Emory "Smith" Bowie, William "Willie" Bowie, Henry Joseph Bowie, and Irving Bowie. (Courtesy Olive Bowie Perry Collection.)

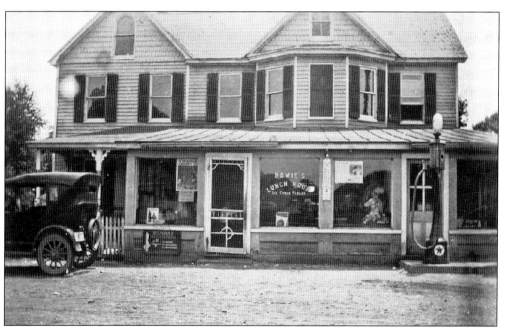

BOWIE LUNCHROOM. The lunchroom was located on Charles Street and managed by the widow Blanche G. Bowie, and was well known as the town of La Plata's first soda and ice cream fountain. Blanche offered a nice discount to the La Plata Volunteer Fire Department. It was located where the La Plata Liquor Store is now. (Courtesy Headen Collection at SMSC, College of Southern Maryland.)

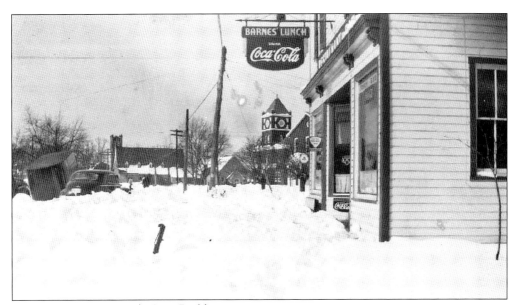

BARNES LUNCHROOM. The Rita Building on Charles Street in La Plata was constructed by Ferdinand Cooksey and named after his daughter. The Barnes brothers, Wallace and Alec, bought it for their ice cream and sandwich establishment. Their humble roots evolved into what became the Stumble Inn. The Barnes Lunchroom is pictured in 1940 looking toward the Charles County Courthouse and Christ Church on Charles Street. (Courtesy SMSC at the College of Southern Maryland.)

BARRY'S DEPARTMENT STORE. Barry Cornblatt was an employee of William L. Dement and the Dement General Store on the corner of Oak and Charles Streets in La Plata. Dement opened the store in 1892, but due to failing health, he passed management duties to Cornblatt, who eventually bought it and renamed it Barry's Department Store. Pictured in front of Barry's store is Julia Homer Wilson, who was visiting Mary Virginia Matthews of La Plata in 1946. (Courtesy Baldus Collection.)

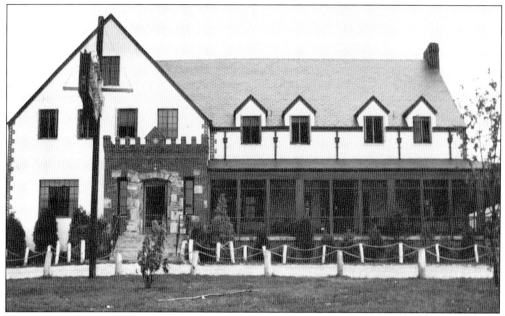

SPRING LAKE HOTEL. Construction crews repeatedly hit springs as they dug the foundation for Clark and Ruby Boswell's lodge-style hotel and restaurant in 1938. It was situated on the newly constructed Route 301 northbound side just before the Prince George's County line. Tragically Clark died before the opening in 1939, and Ruby hired hotel manager Eddie Burroughs in the early 1940s. There were 13 rooms on the second floor and two private apartments on the third floor for Ruby and her son Joseph. The restaurant's banquet room could accommodate 200 customers. Pictured above is the hotel when it was newly built. Pictured below, from left to right, are Joseph Boswell, Ruby Boswell, and Eddie Burroughs. (Courtesy Joseph Boswell.)

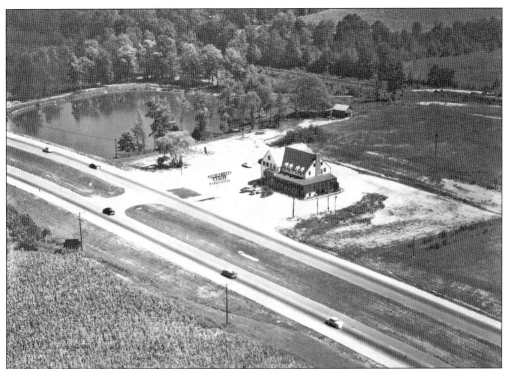

A LAKE IN WALDORF. In about 1945, owner of Spring Lake Hotel Ruby Boswell requested that the State of Maryland create a lake out of the marshland to the left of her property. The state complied and upon completion stocked it with fish for her hotel patrons and locals to enjoy. The photograph shows Crain Highway after it was expanded into dual lanes. (Courtesy Joseph Boswell.)

WALDORF HAIR SALON. Maisy Willett had the first hair salon in Waldorf. The salon was located at the intersection of Route 5 and Route 925 in a small building between the Ben Franklin and the Waldorf Department Store. Before she opened for business, ladies would travel to Washington for their special hair needs. Maisy charged $5 for a permanent wave in the 1950s. (Courtesy Headen Collection at SMSC, College of Southern Maryland.)

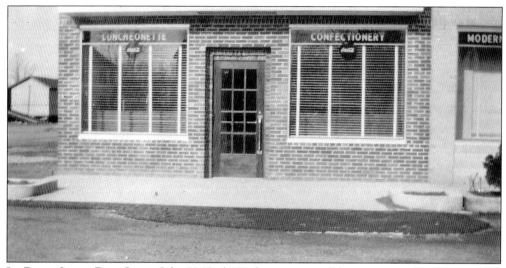

LA PLATA SNACK BAR. Owner John H. "Jack" Taylor constructed this commercial building in 1942 on the spot where the first town hall burned down. The building featured two small commercial spaces and a movie theater. In 1953, Henry Lawlor opened County Drug, where the snack bar was for the theater. County Drug is still operating but under new ownership. The old theater is now home to the Port Tobacco Players theatrical group. (Courtesy Baldus Collection.)

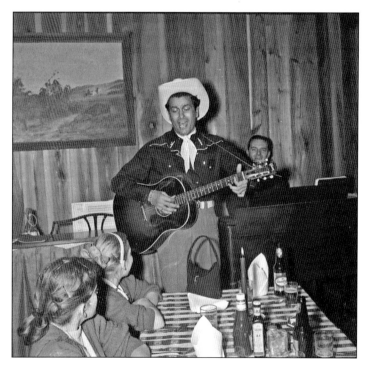

SMITTY'S STEAK HOUSE, BRYANS ROAD. Before opening the steak house, Smitty's Supermarket was already well known for offering custom butcher cuts in their package goods store. Their steak house featured entertainment by a strolling musician and live bands on the weekends. In the 1950s, a steak dinner with salad and sides started at $1.50. (Courtesy Headen Collection at SMSC, College of Southern Maryland.)

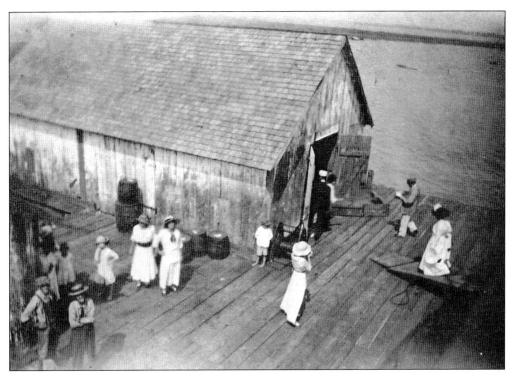

BENEDICT PIER AND RESTAURANT. From colonial times, a pier has been in Benedict. During the early 20th century, steamships like the *Anne Arundel* docked five days a week from Baltimore. The dock featured two large warehouses. The view from the deck of the *Anne Arundel* steamship, gangplank on the right and warehouse in the background, is pictured above. The lady in white, with her hands on her hips and a short necktie, is Mildred Shorter, who was soon to marry George T. Horsman Sr. Pictured below is the pier in the 1940s with a large restaurant on it. The restaurant was open year-round and offered cocktails, dining, dancing, and a casino room. Docking facilities and rental boats, picnic grounds, and a beach for swimming were also available year-round. (Above, courtesy George Howard Post and Judy Ann Post; below, courtesy Dottie Crecelius)

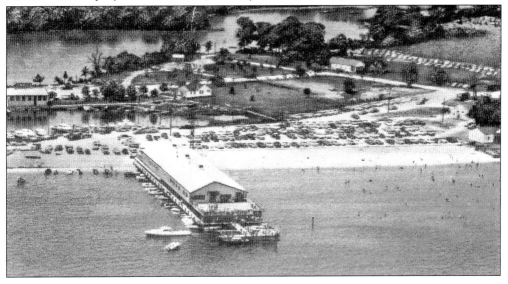

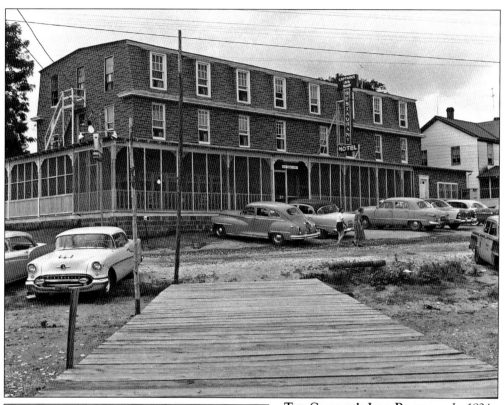

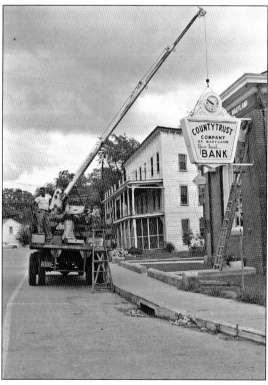

THE CAPTAIN'S INN, BENEDICT. In 1924, it was known as the Hotel Benedict and, in 1931, it was the Schiebel Hotel. By 1954, the hotel was enlarged and completely remodeled with a new dining room and bar that featured dancing music on the weekend to the Elwood Wilson Band, and it was known as the Captain's Inn. The building was purposefully destroyed in the 1960s. The home of Louis Welch is to the right. (Courtesy Headen Collection at SMSC, College of Southern Maryland.)

COUNTY TRUST BANK. The bank was located on Charles Street in La Plata. The building to the left was the La Plata Hotel, then the Bowling Hotel, and is now the location of Casey Jones Restaurant. County Trust Bank was later absorbed by Maryland National Bank, which was eventually acquired by Bank of America. (Courtesy Headen Collection at SMSC, College of Southern Maryland.)

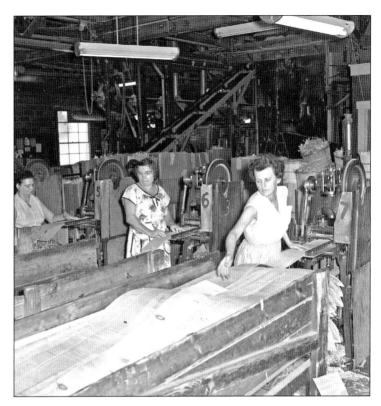

POMONKEY SPOON FACTORY. Delaware factory owner John H. Mulholland moved his wood manufacturing business to Pomonkey in 1946. The factory produced coffee stirrers, popsicle sticks, tongue depressors, and plant markers from the plentiful sweet gum trees that inhabit Southern Maryland. Plant manager Eddie Gilroy ran the six-day-a-week, 24-hour processes until 1970, when it closed. Pictured from left to right are unidentified, Evelyn Scott, and Eleanor Higgs. (Courtesy Headen Collection at SMSC, College of Southern Maryland.)

GEORGIA VILLA RESTAURANT. Owner Eddie Burroughs built the first Georgia Villa Restaurant across from Spring Lake Hotel and Restaurant on Route 301 in Waldorf. Before construction was completed, the Maryland Highway Administration informed him that Route 301 was to be widened, and his business would have to move. He then built this restaurant in 1951 on Route 5 southbound. (Courtesy Headen Collection at SMSC, College of Southern Maryland.)

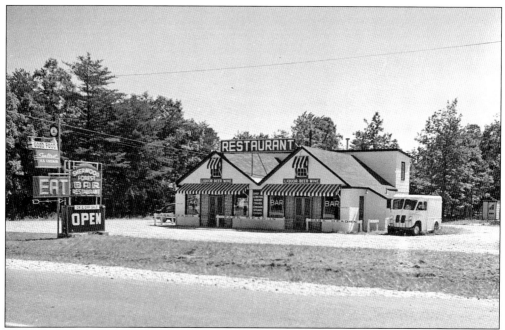

SHERWOOD FOREST RESTAURANT, WALDORF. The 24-hour restaurant was originally located on Route 925 across from Parson's Hall and was owned by ? Jones. The second location was on northbound Route 301 across the street from Raley's Furniture. The business changed hands and was also known as Jim's Las Vegas and then Jean's Las Vegas. (Courtesy Headen Collection at SMSC, College of Southern Maryland.)

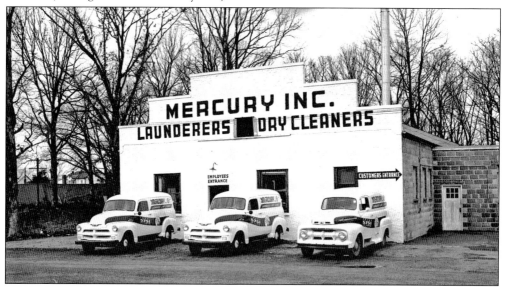

MERCURY LAUNDRY AND CLEANERS. In the 1950s, Mercury Inc. Launderers and Dry Cleaners, located in La Plata, were in competition with Southern Maryland Cleaners, located in Waldorf. Mercury, owned by Larry Sullivan, had pick-up locations in Waldorf. Southern Maryland Cleaners had pick-up locations as far away as Lexington Park in St. Mary's County. Southern Maryland Cleaners, a partnership, was the first to go out of business. (Courtesy Headen Collection at SMSC, College of Southern Maryland.)

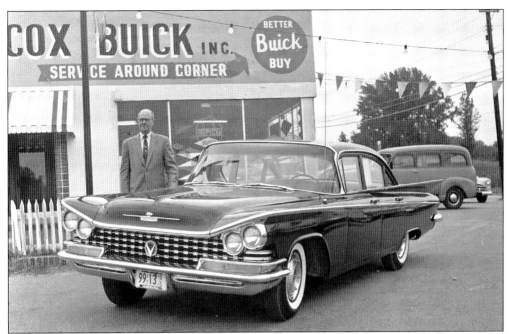

Cox Buick Dealership. The dealership was located on the opposite corner of the Baldus Centre on northbound Route 301 and Route 6 in La Plata. It was formerly Crossroads Buick owned by Hiram Lyon. After Cox went out of business, it became Barnes Chevrolet, then Ritter Chevrolet, and is now the Exxon Gas Station. (Courtesy Headen Collection at SMSC, College of Southern Maryland.)

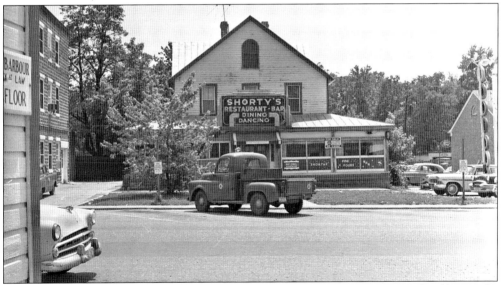

Shorty's Restaurant in La Plata. The restaurant was owned by Shorty Michael and known for its sweet tea and good sandwiches. Conveniently located across from the courthouse on Charles Street, it was a popular meeting place for attorneys. Pictured from left to right are the home of the C&P Telephone Company, formerly the Matthews-Howard Building; the restaurant; and the modern 1957-version of Martin's Garage. (Courtesy Headen Collection at SMSC, College of Southern Maryland.)

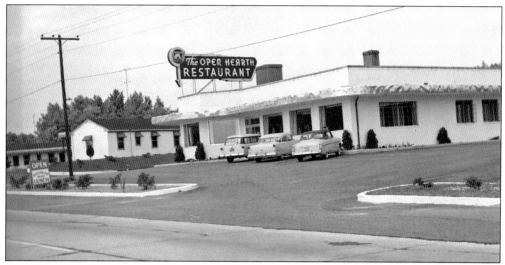

OPEN HEARTH RESTAURANT. The Open Hearth was the second restaurant owned by Shorty Michael in La Plata. It featured businessmen's lunch specials and was used by many local clubs for their special occasions. To the left of the restaurant is the La Plata Motel, owned by Jack Simpson and then sold to Lowell Hawthorne. The Open Hearth is now Colonial Liquors and Fine Wines on Route 301. (Courtesy Headen Collection at SMSC, College of Southern Maryland.)

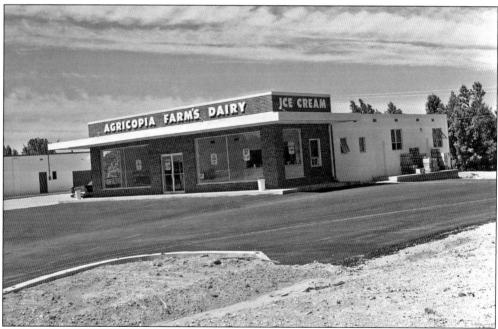

AGRICOPIA DAIRY STORE. Located on southbound Route 301 in La Plata, the store was built by Harry Turner as a milk processing and bottling plant for his dairy farm. The front area was a retail ice cream store. The farm was at the current location of the Agricopia Housing Development on Route 488. Agricopia later became part of the Sealtest brand of dairy products. (Courtesy Headen Collection at SMSC, College of Southern Maryland.)

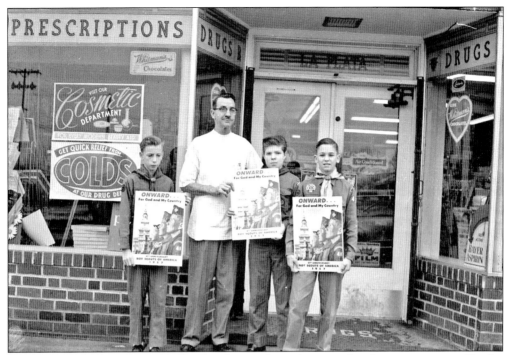

LA PLATA METRO DRUGSTORE. The Boy Scouts shown here are distributing posters to Charles County businessmen during Boy Scout week in 1957. Pictured from left to right are Alan Cruikshank, who became the head of the Soil Conservation Service in La Plata; Edwin E. Fraase; Jack Mitchell, who became an attorney; and David Scherr. (Courtesy Headen Collection at SMSC, College of Southern Maryland.)

METRO DRUGSTORE LUNCH COUNTER. Gone are the days of a 25¢ sandwich and a 35¢ hot fudge sundae. When customers walked into the store, the smell of freshly roasted peanuts greeted them. The toy section offered boat and car models for 69¢. The drugstore was built in about 1953 in La Plata where the Baldus Centre now grandly sits. (Courtesy Headen Collection at SMSC, College of Southern Maryland.)

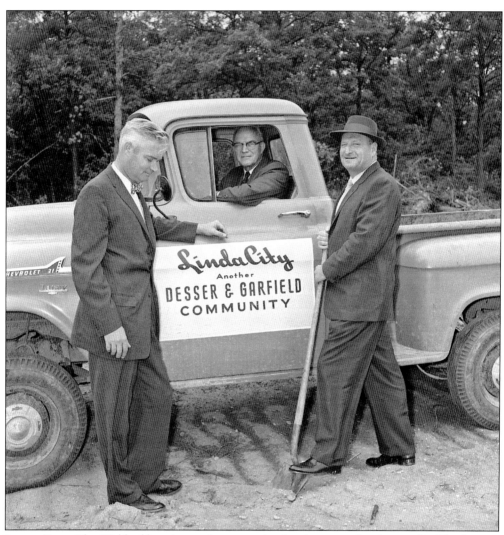

LINDA CITY. The Waldorf housing and community development that is now St. Charles was first developed as Linda City by the Miami firm of Desser and Garfield in 1958. Interestingly Desser and Garfield were both one-time directors of Meyer Lansky's Miami bank. Desser and Garfield declared bankruptcy by 1961. Prior to Desser and Garfield's purchasing of the large tract, Rep. Frank Boykin purchased the 8,000 acres with hopes that the site would be chosen for an alternative Washington airport. It was to be Dulles Airport, but plans failed. Boykin also considered entertainment venues that included a horse racetrack, a car racing dirt track, and a baseball stadium before selling it to Desser and Garfield. Plans for a baseball stadium had been on the maps since 1964 and were finally realized in 2007. In 1968, St. Charles was designated a federal town under the ownership of American Interstate General and accessed HUD financing and grants to develop its infrastructure. It is now managed by the American Community Properties Trust. Pictured in 1958 breaking ground are, from left to right, Pat Mudd, clerk of the court; Asa Groves, Waldorf project director; and Arthur A. Desser, with shovel. (Courtesy Headen Collection at SMSC, College of Southern Maryland.)

TERCENTENARY CELEBRATION AT LINDA CITY. The Desser and Garfield Development Company began work on Linda City in 1958, the same year Charles County celebrated its 300th anniversary. The gala program featured a historical pageant titled "Our Heritage" that was held at Chapel Point. Pictured is the billboard for Linda City's coming out, a perfect way to advertise both. (Courtesy Headen Collection at SMSC, College of Southern Maryland.)

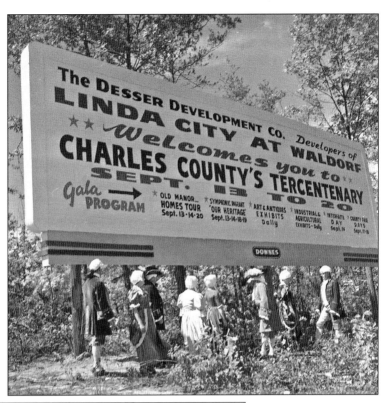

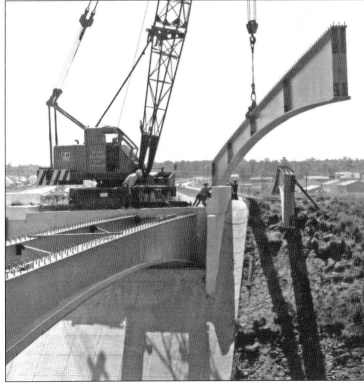

ST. CHARLES COUNTRY ESTATE LIVING. Built in 1958 for what was then Linda City, this is the only bridge over the railroad tracks in Charles County running north to south. Notice the houses in the background with no trees. Initially the homes were built in only four styles: Prince Lawrence, Prince Charles, Prince Edwards, and Prince William. The least expensive Prince Lawrence sold for $16,490 with a monthly payment of $124. (Courtesy American Community Properties Trust.)

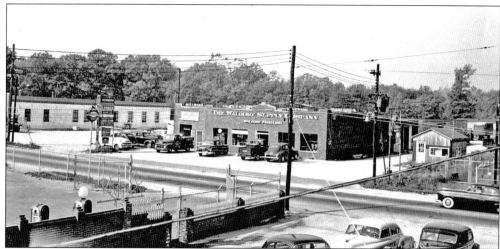

WALDORF SUPPLY COMPANY. In 1957, a fire destroyed the business owned by Gene Goddard, which prompted the reorganizing and eventual chartering of the Waldorf Volunteer Fire Department in 1959. The building supply company was located on Route 925 and is now the current location of the Waldorf VFD. The gated property across the street is Pargas, a bottled gas company. (Courtesy Headen Collection at SMSC, College of Southern Maryland.)

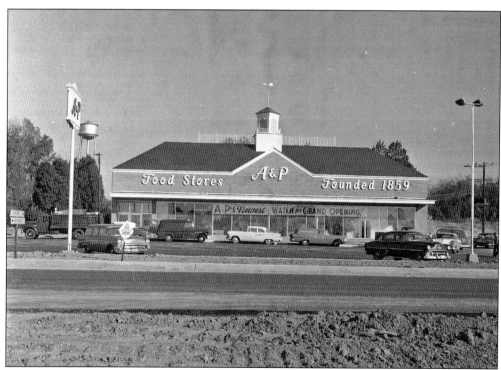

A&P GROCERY STORE. Originally a small A&P grocery store was located on Charles Street in La Plata between Barry's Department Store and County Trust Bank. By October 1958, a new, modern A&P supermarket was built on Route 301 near Charles Street. It was advertised as a self-service market and offered shoppers a pint of fresh oysters for 95¢. (Courtesy Headen Collection at SMSC, College of Southern Maryland.)

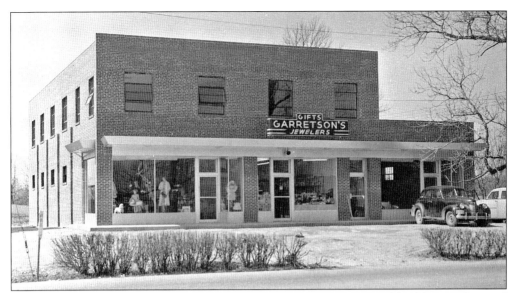

HOWARD BUILDING. Wilhelmina Howard constructed this commercial building on Route 5 southbound in 1952 to accommodate her sister Eleanor Greenwell's ladies apparel store, the Smart Shoppe. Greenwell bought the business from her previous employers when the store was located in the old Carlton Hotel. Pictured from left to right are the Smart Shoppe, Garretson's Jewelers, and Doc Rosenstein's Pharmacy and Drugstore. (Courtesy Headen Collection at SMSC, College of Southern Maryland.)

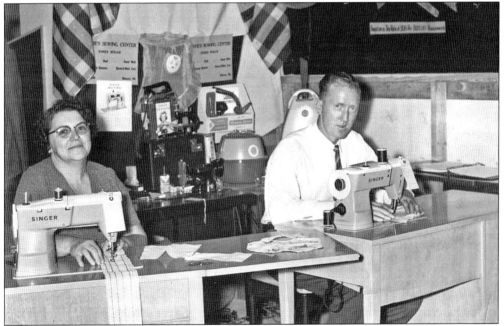

LA PLATA SEWING CENTER. Mary Elizabeth Bowie opened the sewing center on Charles Street in the 1960s. She was the first Maryland woman to have a franchise with Singer. The store offered material, McCall patterns, vacuum cleaners, alterations, and sewing machine repairs. The store closed in 1973, and then Mary Elizabeth became co-owner of Goose Bay Marina. Pictured from left to right are Mary Elizabeth and an unidentified man. (Courtesy Olive Bowie Perry Collection.)

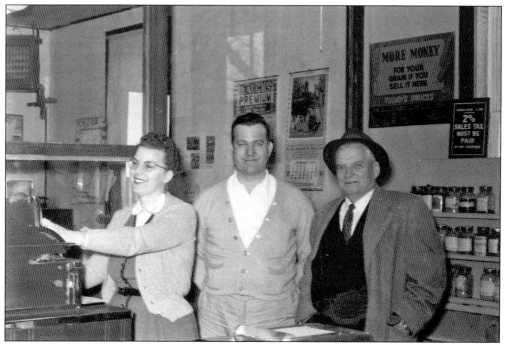

MARYLAND TOBACCO GROWERS ASSOCIATION STORE. The co-op store in Waldorf enabled farmers to buy necessities such as fertilizer, feed, seed, and tools at a lower price. It was overseen by the general manager of the Maryland Tobacco Growers Association in Baltimore, Samuel C. Linton Sr., and managed by Fritz Bender. Fritz's wife, Arabelle Jenkins Bender, was bookkeeper. Pictured from left to right are Arabelle and Fritz Bender and Samuel C. Linton Sr. (Courtesy Bender Collection.)

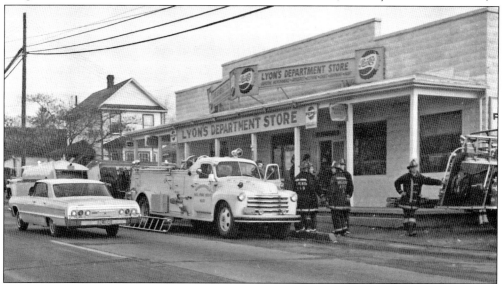

LYONS DEPARTMENT STORE IN HUGHESVILLE. The Matthews family managed the department store owned by Webb Lyon that became an integral part of the community, in part because of the 2,400-square-foot walk-in freezer known as "the locker" in which locals could rent space for their frozen food storage. Pictured is the Hughesville VFD responding to a small fire in the store in 1963 or 1964. The building is now an antique store. (Courtesy Ed Keller.)

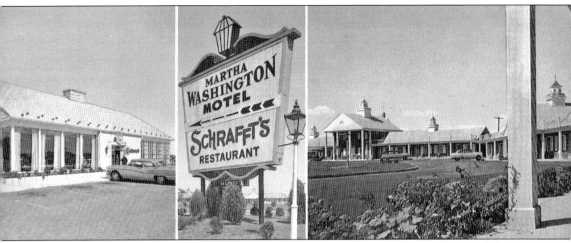

A SCHRAFFT'S RESTAURANT FRANCHISE. In 1953, Judge John Celentano of New Jersey and three partners from New Jersey opened a Schrafft's Restaurant franchise in connection with a motel already established on Route 301 in Waldorf. It was the first Schrafft's franchise in the state of Maryland. Celentano's brother-in-law and sister-in-law, John and Vivian Arata, managed it. The restaurant was opened in 1961 and featured two levels: a main floor that seated 70, with a soda fountain and counter that sat 18, and a banquet room downstairs, the Plantation Room, that accommodated 350. Pictured from left to right are a postcard of the restaurant, the sign, and the Martha Washington Motel office. (Courtesy George and Judy Arata.)

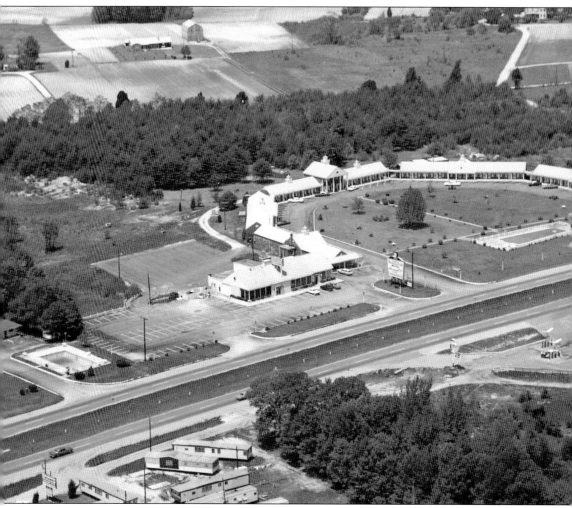

Martha Washington Motel and Restaurant. When the motel and restaurant closed in 1969–1970, it was sold to Melvin and Helen Downes and is now the location for the Sam's Club store on southbound Route 301. Where the pool once was is now the Bob Evans Restaurant. Pictured above is an aerial view of the restaurant and motel. The farm behind belonged to Howard Garner, who owned Howard's Restaurant. Surrounding the motel and restaurant is the typical Maryland woodland scene that gave Waldorf its name, derived from a German word meaning "village in the forest." (Courtesy George and Judy Arata.)

Five
SERVICE CLUBS

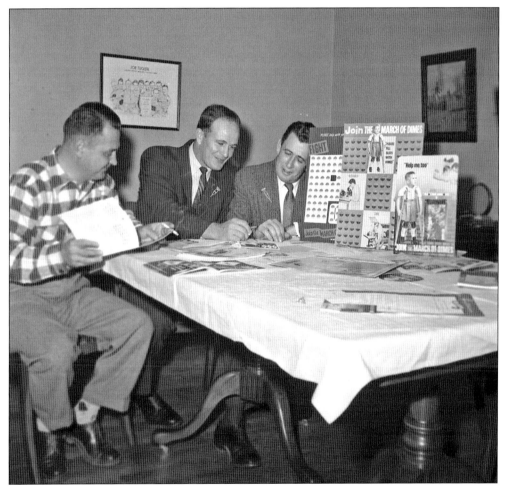

MARCH OF DIMES POLIO DRIVE. In 1955, the Infantile Paralysis Foundation developed a polio vaccine after $9 million was raised. Charles County raised $6,000, and half of that came back to aid its own by vaccinating first and second graders. By 1979, the last wild polio virus occurred in the United States. Pictured from left to right are Mike Floyd, treasurer; Joe Tucker; and Larry Sullivan, president of the Charles County chapter. (Courtesy Headen Collection at SMSC, College of Southern Maryland.)

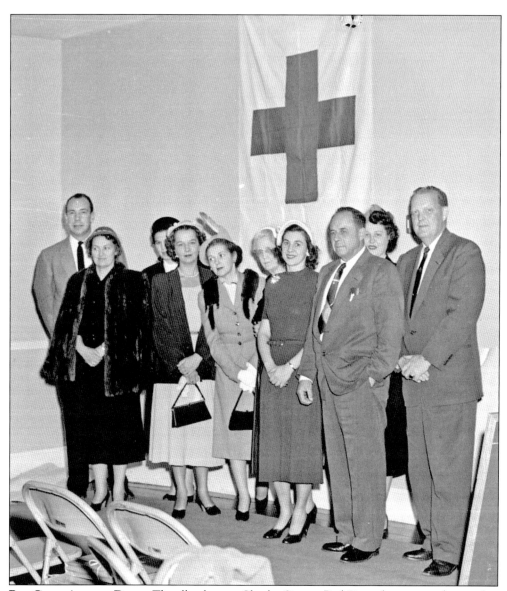

RED CROSS ANNUAL DRIVE. The all-volunteer Charles County Red Cross chapter was chartered in 1917. This photograph shows the kick-off fund-raiser of 1954 that was held at the Hawthorne Country Club. Pictured from left to right are chairman of the drive Reed McDonagh, Mrs. C. E. Wright, Mrs. J. A. Herbert, Mrs. Robert Hare, Mrs. John Hanson Mitchell, Mrs. George I. Gardiner, senior chapter chairman Mardalee B. Crane, W. C. Abell, Mrs. P. C. Henderson Jr., and W. H. Wheatley. Approximately 60 other persons attended the meeting. (Courtesy Headen Collection at SMSC, College of Southern Maryland.)

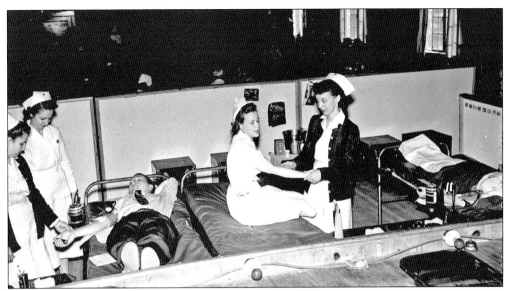

RED CROSS BLOOD DRIVE. In 1956, a blood drive was held at the Christ Church parish hall in La Plata. Local nurses volunteered their services. These were the days when glass transfusion bottles were used and needles were sterilized and reused. Seated in the middle of the photograph in white is Kitty Mitchell Claggett, nurse of Dr. Edelen and Physicians Memorial Hospital. The others are unidentified. (Courtesy Headen Collection at SMSC, College of Southern Maryland.)

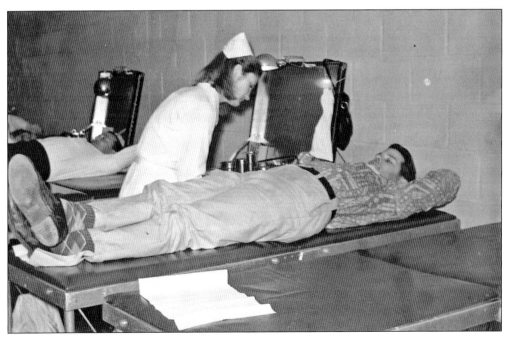

WALDORF LIONS CLUB BLOOD DRIVE. The Red Cross bloodmobile has been a regular at the Waldorf firehouse since the 1960s, and the Waldorf Lions Club always sponsored the drive. The Waldorf VFD Ladies Auxiliary provided snacks. Pictured on the table in the foreground is veteran firefighter William F. Cooke, and all others are unidentified. The photograph was taken by Ed Keller, at the time a freelance photographer for the *Times Crescent* newspaper. (Courtesy Ed Keller.)

LIONS CLUB ANTIQUE SHOW. The antique shows between 1954 and 1960 were held at the National Guard Armory in La Plata. Pictured from left to right are Louise Arehart, whose husband was chairman of the show; lion member Calvin Compton Sr.; lion member Joe Popadal; Pearl Jones, antique dealer coordinator; and lion member Paul Gardiner. (Courtesy Headen Collection at SMSC, College of Southern Maryland.)

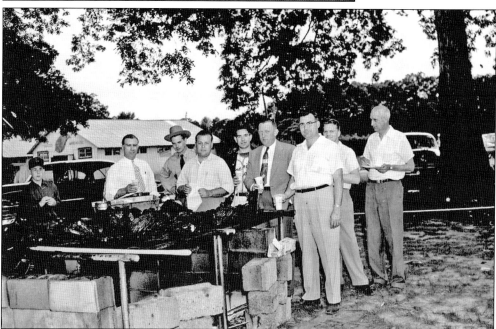

LIONS CLUB BBQ FUND-RAISER. For many years, the Lions Club was responsible for hanging the Christmas lights for the town of La Plata as well as paying the town's electricity bill for their streetlights. Pictured from left to right are Tommy Hayden, lion Sam Vacchiano, trooper Bill Earl, unidentified, lion Clifford Hayden, lion Benjamin Drury, lion Foley Mattingly, unidentified, and lion Franklin Winkler. (Courtesy Headen Collection at SMSC, College of Southern Maryland.)

Charles County Garden Club. By the 1950s, Route 301 had become a divided highway and the garden club adopted the bare median as part of their beautification program. Planting trees from left to right are Doris Ackerbloom; Gertrude Coburn; Kitty Mitchell, who was president from 1973 to 1975; and Margaret Brown. (Courtesy Headen Collection at SMSC, College of Southern Maryland.)

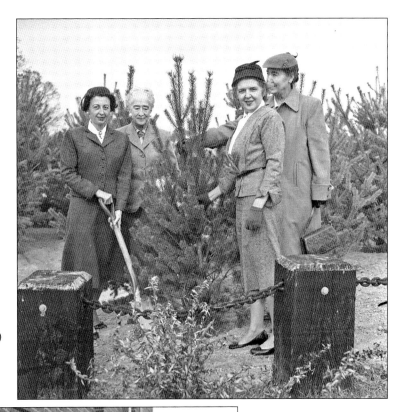

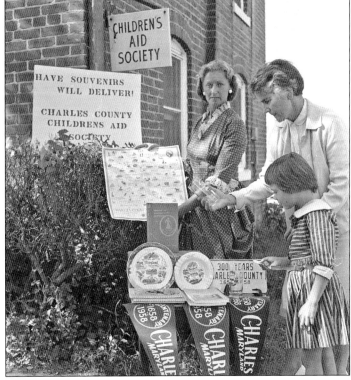

Children's Aid Society. The Charles County group started in 1936 to find friends for abused, abandoned, and neglected children. They worked under the direction of the courts in cooperation with the county commissioners and at the request of relatives and friends of the abused children. Pictured in front of the old La Plata jail are, from left to right, volunteer Fran Norris and two unidentified. (Courtesy Headen Collection at SMSC, College of Southern Maryland.)

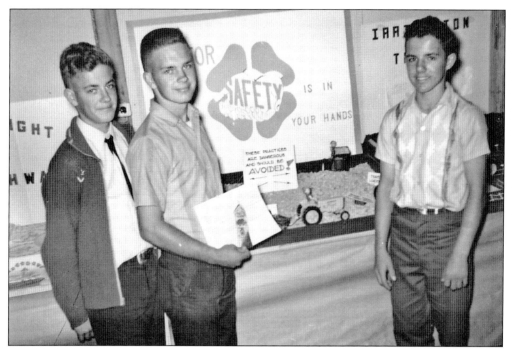

4-H CLUB. The club is part of the Maryland co-op extension agency and has been active in Charles County for over 50 years. They offer a variety of farm-related activities in which to participate. Pictured above is the Pioneer 4-H Club of Waldorf in the Maryland State Fair of 1964. They won grand champion for a tractor safety exhibit. From left to right are Lenny Arch, Tony Arch, and Alfred Epp. Pictured below are La Plata 4-H members beautifying the traffic circle, which was once in the middle of Charles Street, with colorful annuals. In the background is the County Drug Store, owned at the time by Henry Lawlor. Pictured from left to right are Debbie Barnhart, Ethel "Footie" Seay, unidentified, and Mary Catherine Miller. (Above, courtesy Ed Keller; below, courtesy Headen Collection at SMSC, College of Southern Maryland.)

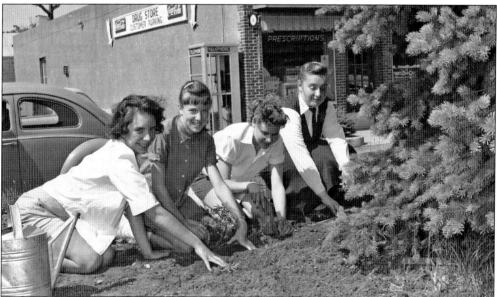

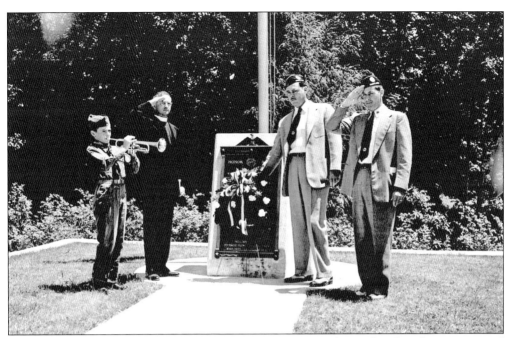

AMERICAN LEGION'S MEMORIAL SERVICE. On June 4, 1954, a wreath was placed on the war memorial located at the Harry White Wilmer Post of the American Legion in La Plata during Memorial Day services. The legion was started in 1946 and named for a World War I hero. From left to right are Tommy Bowling, Boy Scout bugler for the legion's Scout troop; chaplain Rev. Marc Nocerino; Sergeant-at-Arms Bill Fraser; and Comdr. Walter Rees. (Courtesy Headen Collection at SMSC, College of Southern Maryland.)

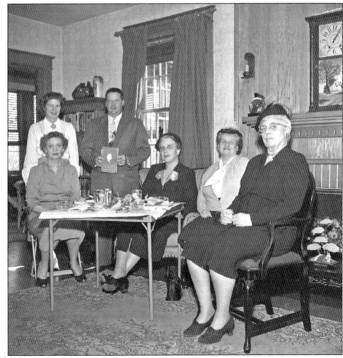

WOMEN'S CLUB OF SOUTHERN MARYLAND. In 1954, the club had five categories of interest: home life, education, international affairs, legislative activities, and environment. It is now called the Charles County Women's Club. From left to right are (seated) Mrs. J. E. Andrews; Theresa Olivia Wills McDonagh, president; Mrs. Tilgham H. Keiper, vice president; and Mrs. Foster Reeder, acting correspondence secretary; (standing) Elizabeth Hart, treasurer, and John Sullivan, speaker. (Courtesy Headen Collection at SMSC, College of Southern Maryland.)

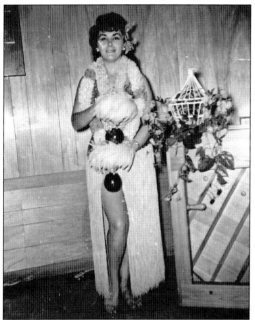

MOOSE LODGE. The lodge located in White Plains on Route 301 was started in 1953 with approximately 50 members. They were open-handed to the needy and supported various other charitable groups that included the American Cancer Society and the Muscular Dystrophy Association. In 1963, the ladies of the Waldorf Moose Lodge held an all-lady fund-raising follies called the Hawaiian Chorus. Pictured is winner Louis Paxson. (Courtesy Ed Keller.)

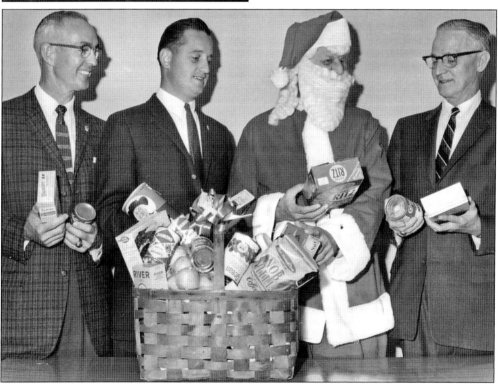

IMPROVING SOUTHERN MARYLAND. Many church and service groups of Southern Maryland were active in helping those in need. Pictured are a few Waldorf Lions Club members in 1963. They helped collect food and toys for gift baskets that brightened Christmas for many. Pictured from left to right are Walt Smith, past president of the Lions Club; Jim Simpson, then president of the Lions Club; Dick Saunders who was playing Santa; and Forrest Coakley. (Courtesy Simpson Collection.)

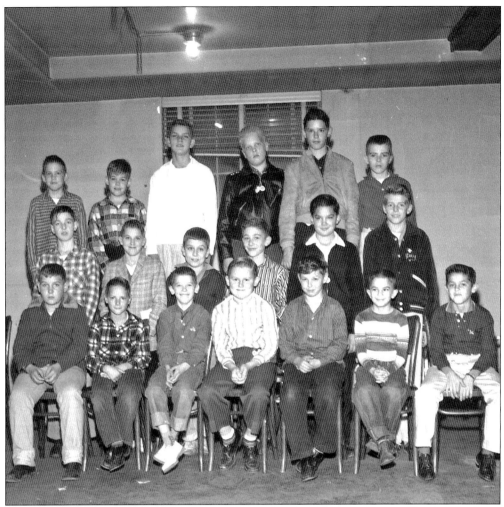

WOODMAN OF THE WORLD. This Charles County Boys Club was a branch started by the Woodman of the World insurance company that promoted the love of God, country, body, and mind. Meetings were held at the Spring Lake Hotel. From left to right are (first row) Michael Woods, Leon Gough, George O. Lyon, Gary Guy Berry, unidentified, Rickey Nanhas, and George Arata; (second row) Richard Puryear, Philip Hamilton, two unidentified, Ernie Renner, and Joe Thir; (third row) Ronnie Head, Franklin Rosenstein, unidentified, Tommy Jenkins, unidentified, and Dennis Welch. (Courtesy Headen Collection at SMSC, College of Southern Maryland.)

IZAAK WALTON LEAGUE. Chicago sport fishermen concerned about water pollution started this national club in 1922. The league's namesake was the author of the most-renowned book on the subject at the time, the *Compleat Angler*. The Charles County chapter formed in 1958, now the Southern Maryland chapter, and made the Zekiah Swamp their initial focus. Pictured are members in 1955 releasing turkeys into the wild. (Courtesy Headen Collection at SMSC, College of Southern Maryland.)

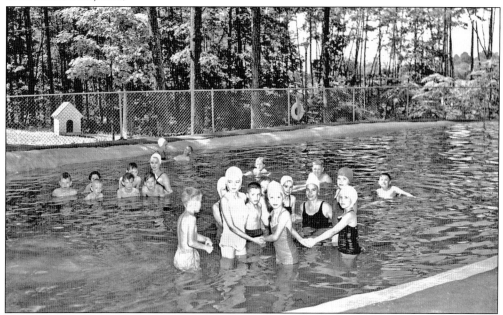

WATER SAFETY COURSE. In 1958, the Red Cross provided free swimming classes five days a week for two weeks, ranging from beginner to junior lifesaver. Pools were located at motels, local beaches, and private homes. The water safety coordinator for Charles County was Mrs. Forest Coakley. Pictured is a class in the private pool of Pargas president C. J. McAllister. (Courtesy Headen Collection at SMSC, College of Southern Maryland.)

Six

LAW AND ORDER

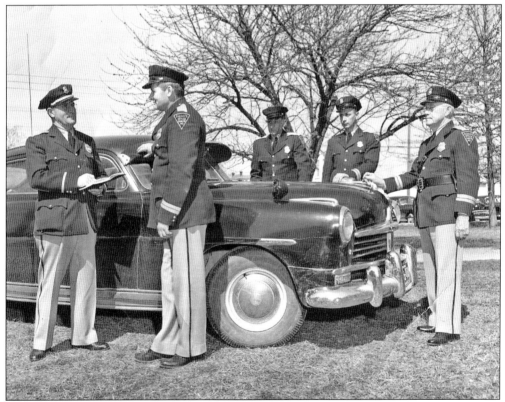

NEW SHERIFF'S DEPARTMENT VEHICLE, 1951. A Hudson automobile was the vehicle of choice for the sheriff's department in 1951. The same vehicle was chosen to play the judge in the animated movie *Cars*. Pictured in the back of the courthouse are, from left to right, Sheriff Robert Vernon Cooksey; deputy Henry Bettinson Albrittain; deputy Avery C. Monroe, a future sheriff; Tommy Shymansky; and Hampton Cox. (Courtesy Buddy Garner.)

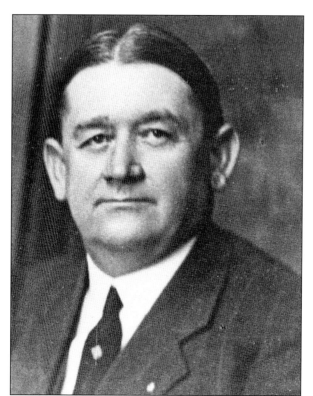

SHERIFF LEO KERVICK FARRALL. Born in 1885, Farrall registered for both World War I and World War II. As a child, Farrall was a typesetter for the *Maryland Independent*. His career was mainly as a traveling salesman to Southern Maryland counties for the Loewy Drug Company of Baltimore for 40 years. Even while sheriff from 1917 to 1918, he still worked as a salesman. (Courtesy Charles County Sheriff's Department.)

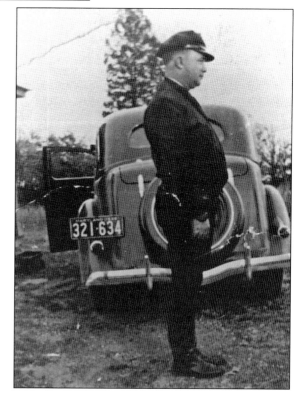

DEPUTY HAROLD RICE. Rice was a full-time engineer for the Baltimore Potomac Railroad at the same time he was a part-time sheriff's deputy under Sheriff Russell Howard from 1936 to 1960. During the early years, he was paid on an annual basis by the county commissioners per disturbance he answered. He even kept his own records of each disturbance. (Courtesy Charles County Sheriff's Department.)

SHERIFF ROBERT VERNON COOKSEY. Cooksey was a Charles County deputy sheriff in 1926 when his father was sheriff, was sheriff himself from 1930 to 1934, a state senator from 1934 to 1938, in the House of Delegates from 1946 to 1950, and sheriff again from 1950 to 1954. As sheriff, he lobbied for a bill that provided radio-equipped county cars and helped to establish the sheriff department's 24-hour operation in 1953. Cooksey is pictured disposing of moonshine. (Courtesy Headen Collection at SMSC, College of Southern Maryland.)

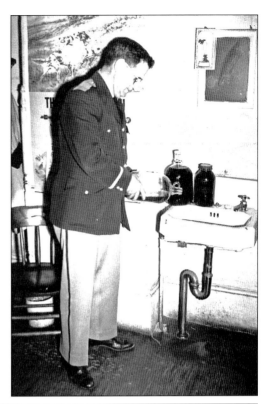

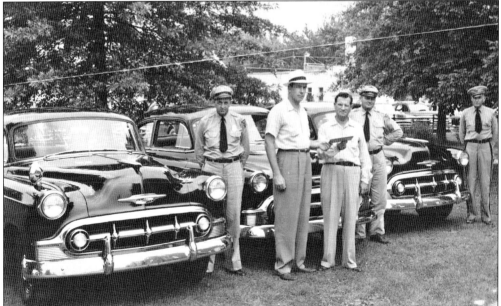

NEW CHARLES COUNTY SHERIFF VEHICLES. Sheriff Robert Cooksey took delivery of three new Chevrolet patrol cars purchased from the McDonagh Chevrolet dealership in 1953. Pictured from left to right are Deputy Sheriff Francis Murphy, Reed McDonagh, Sheriff Cooksey, deputy Henry B. Albrittain, and deputy Avery C. Monroe. The cars patrolled Charles County's 502 square miles and helped protect the 1953 residential population of 23,415. (Courtesy McDonagh Collection.)

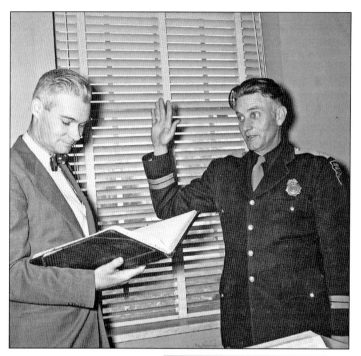

SHERIFF AVERY MONROE. Avery C. Monroe was born and raised in Nanjemoy, served as an army sergeant on a special mission in Cairo during World War II, and was county commissioner before he became sheriff in 1954. Unfortunately, Sheriff Monroe died from illness in 1958 just before his four-year term was up. He is buried at Arlington National Cemetery. In the picture, Pat C. Mudd, clerk of the court, swears in Sheriff Monroe. (Courtesy Charles County Sheriff's Department.)

SHERIFF'S LITE A BIKE PROGRAM. In 1954, the Potomac Heights Safety Committee requested assistance from the Charles County Sheriff's Department in keeping children safe while riding their bikes in the small neighborhood. Pictured registering children's bicycles and applying reflector tape to them are, from left to right, Deputy Sheriff Clarence Carpenter, Michele Drzeweickie with her bicycle, and Sheriff Avery Monroe. (Courtesy Charles County Sheriff's Department.)

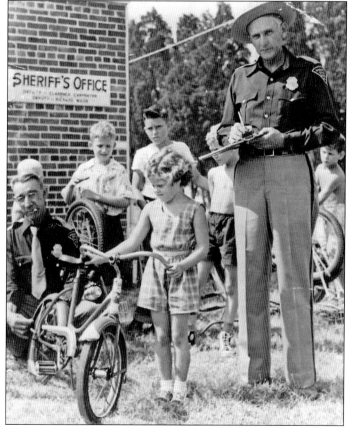

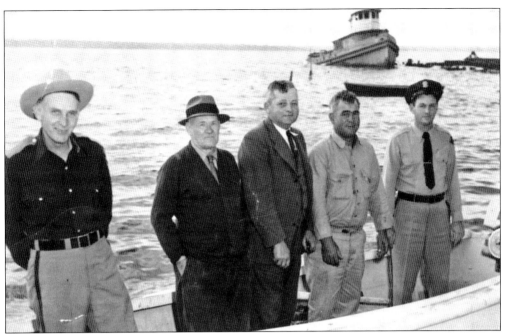

MARYLAND'S OYSTER WARS. Jurisdiction of the Potomac River to the shore of Virginia that favored Maryland in a 1785 treaty stood the test in 1957 when it reached the Supreme Court. Maryland law banned Virginians from oyster dredging and harvesting, which became as big a problem as bootleg whiskey. Pictured from left to right are Sheriff Avery Monroe; Bruce Wilmer, Popes Creek special water deputy; deputy Henry Albrittain; and two unidentified. (Courtesy Charles County Sheriff's Department.)

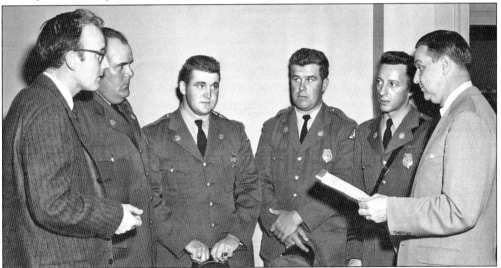

MARYLAND MARINE POLICE. Shots were often exchanged from poaching Virginians to Maryland law enforcement during the oyster wars. An early branch of law enforcement for that problem was the Maryland Marine Police, whose service is now performed by the Department of Natural Resources. Pictured in court for a legal battle from left to right are George W. Bowling, state's attorney; two unidentified; Harvey Cooke, Maryland marine policeman; unidentified, and Edward Digges, attorney for the county commissioners. (Courtesy Buddy Garner.)

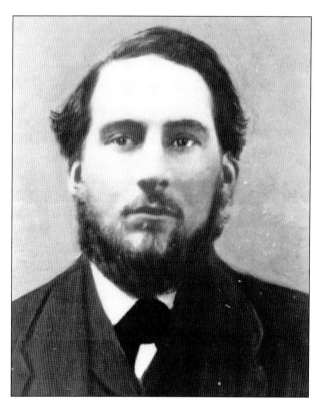

Sheriff John Warren Albrittain Jr. John Warren served twice as a Charles County sheriff for two-year terms in 1893 and 1907. He was also a tobacco farmer and buyer. His farmstead, located on Route 6 west, was comprised of almost 1,000 acres and named Part of Plenty. It stretched from Stagecoach Road to just across Route 6. (Courtesy Charles County Sheriff's Department.)

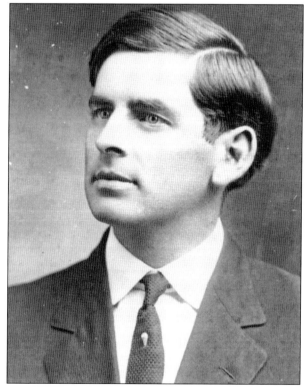

Sheriff Lemuel Albrittain. Lemuel, son of Sheriff John Warren Albrittain Jr., was a Charles County deputy from 1907 to 1909, sheriff from 1915 to 1917, and then spent 10 years as a probation officer. He was also a general store merchant in Bel Alton until it closed in the 1960s. Lemuel lived at the Wills Hotel with his wife, Mary Louise Wills, and several children. (Courtesy Charles County Sheriff's Department.)

HENRY BETTINSON ALBRITTAIN. Henry, also the son of Sheriff John Warren Albrittain Jr., lived in Charles County near Port Tobacco for the first 20 years of his life. He then went to St. Louis, Missouri, in 1924 to learn how to be a plumber. He met and married Leona Clara Steiner and returned to Charles County. He was a familiar figure at the Charles County Fair by being very active in local politics and a number of farm organizations. He served as a deputy sheriff from 1944 to 1968. After retiring, his farm became well known by local schoolchildren as the "petting zoo." (Courtesy Albrittain Collection.)

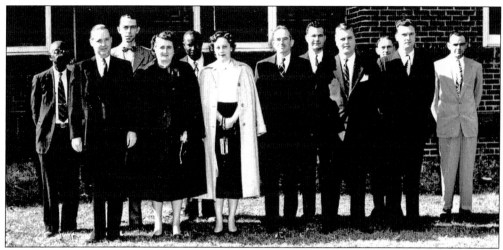

FIRST WOMEN JURORS. It was in 1953 that the first female jurors served on a Charles County jury. Pictured outside the courthouse from left to right are unidentified; George I. Gardiner; unidentified; Anna Swann Wills, home demonstration agent for the county extension service; unidentified; Margaret Addison, manager of Marshall Hall Amusement Park; unidentified; Henry Albrittain; Louis Jenkins, attorney; and three unidentified. (Courtesy Headen Collection at SMSC, College of Southern Maryland.)

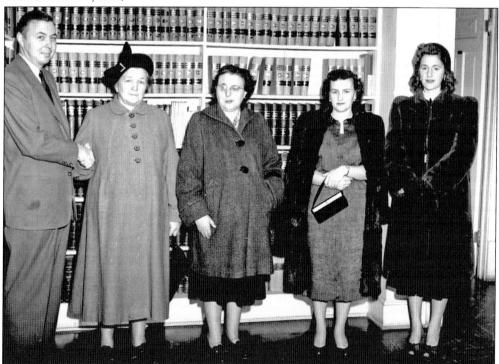

NATURALIZATION SESSION IN 1954. Judge J. Dudley Digges welcomes four new American citizens on January 4, 1954, at a session of naturalization court at the Charles County Courthouse. Pictured from left to right are Judge J. Dudley Digges, Grace Keller of Waldorf, Blanche Edemon of Lexington Park, Harriet Posey of Indian Head, and Peggy St. Clair of Newport. (Courtesy Headen Collection at SMSC, College of Southern Maryland.)

Deputy Sheriff Ritchie Vernon. Ritchie "Spike" Vernon was a bus driver on the navy yard grounds before becoming a deputy sheriff in the 1950s. Vernon's winter uniform consisted of a shoulder strap used to hold the weight of the belt in which he holstered his .38 and bullets. If anyone grabbed the officer from behind by that strap, they controlled him. In 1967, one that detached in a hand-to-hand situation was adopted. (Courtesy May and Rose Howard.)

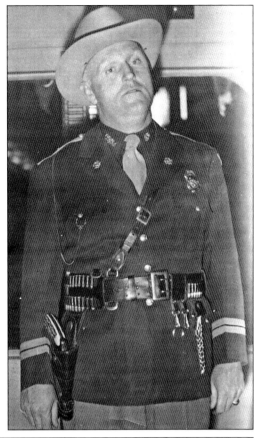

Summer Uniforms for Sheriff. In May 1954, the sheriff and deputies posed in front of the courthouse in their new uniforms. Pictured from left to right are (first row) deputies Robert Brawner and Clarence Carpenter and incoming Sheriff Avery Monroe shaking outgoing Sheriff Robert Vernon Cooksey's hand; (second row) deputies Ritchie Vernon, Henry Stine, Francis Murphy, and Henry Albrittain. (Courtesy Headen Collection at SMSC, College of Southern Maryland.)

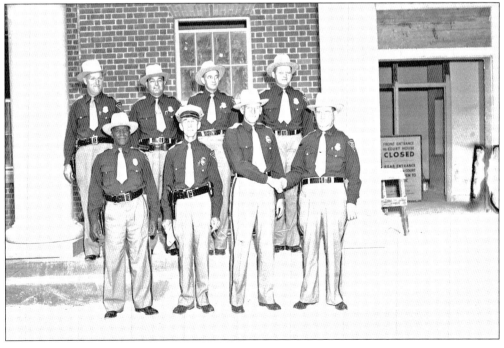

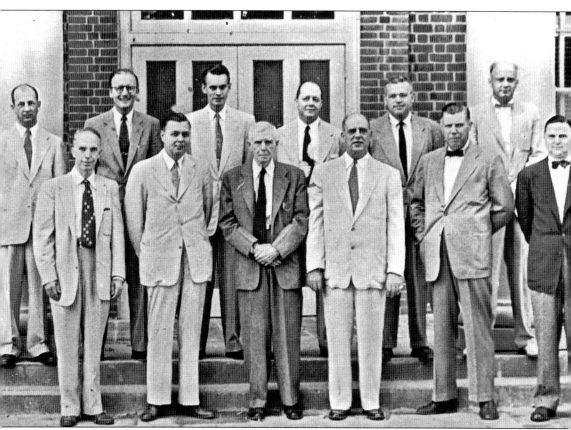

CHARLES COUNTY BAR IN 1954. The Charles County Bar Association formed in the early 1950s. This photograph is believed to be of the first members. Pictured from left to right in 1954 are (front row) James Craik Mitchell, who became a judge on December 24, 1969; John Dudley Digges, who became a judge on November 25, 1969; Judge Walter J. Mitchell; and attorneys Rudolph A. Carrico, F. DeSales Mudd, and Edward S. Digges; (second row) Thomas C. Carrico, attorney; George W. Bowling, Charles County state's attorney from 1955 to 1963 then county administrative judge in 1975; Eugene A. Jenkins, attorney; Robert T. Barbour, attorney; Maurice Flynn; and John C. Hancock, who was state's attorney from 1963 to 1975. (Courtesy Public Law Library at Charles County Courthouse.)

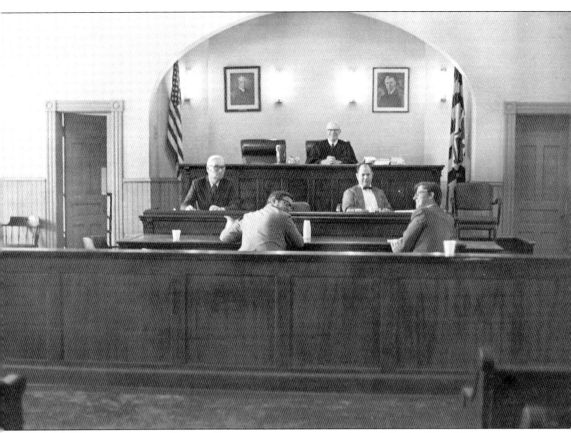

CHARLES COUNTY CIRCUIT COURT. During a massive renovation of the La Plata Courthouse in 1973, the circuit court was temporarily held in the Christ Church parish hall. Pictured is the last jury trial in the original courtroom that was built in 1895. Pictured are, from left to right, (first row) attorney John Mudd and deputy state's attorney Chris Nalley; (second row) court clerk Patrick Mudd and court reporter John Ferrell. Presiding on the bench is Judge James C. Mitchell. The attorney at far left (only a portion of his body is seen) is Richard Clark, later a circuit judge. (Courtesy Nalley Collection.)

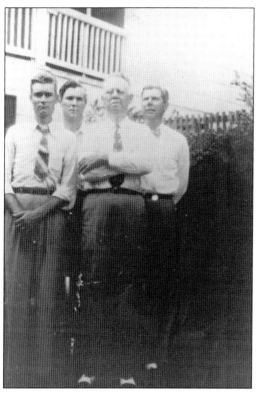

LEGAL EAGLES. John Francis Mudd was admitted to the Maryland Bar Association in 1907. When his son, Francis DeSales Mudd, joined him in the business of law in 1933, they created the law firm of Mudd and Mudd. Pictured from left to right are Patrick Conroy Mudd, clerk of the court; John Turner Mudd, who operated the Bryantown General Store; John Francis Mudd; and Francis DeSales Mudd, attorney. (Courtesy Mudd Collection.)

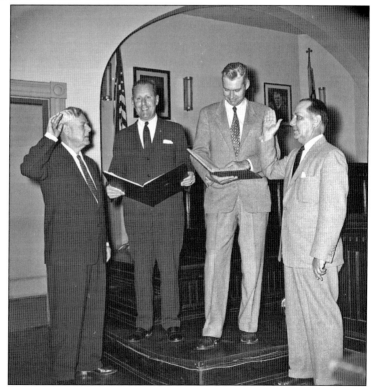

CHARLES COUNTY SENATOR APPOINTED. In April 1957, Thomas B. R. Mudd was appointed state senator for Charles County when James B. Monroe resigned. At the same time, Monroe took the oath of office for Maryland Motor Vehicle Administration commissioner, vacated by Mudd. Pictured from left to right are Mudd; Louis Goldstein, senate president; Patrick C. Mudd, clerk of the court who administered the oath; and Monroe. (Courtesy Headen Collection at SMSC, College of Southern Maryland.)

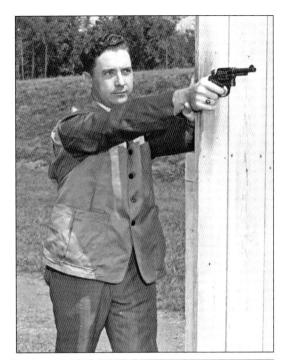

SHERIFF FRANCIS "BUDDY" GARNER. Garner was a deputy before entering the FBI National Academy in preparation for becoming sheriff of Charles County. He graduated from the academy in 1958 and was appointed by Sheriff Avery Monroe before Monroe died of cancer. Garner won the election and served as sheriff from 1958 to 1978. Garner is pictured at the FBI firearms range on the U.S. Marine Corps Base in Quantico, Virginia. (Courtesy Buddy Garner.)

LAWFUL LOITERING. It was unusual to see two deputy sheriffs in the same place at the same time, mainly because during the mid-1950s there were only two deputies working one 12-hour shift. Only in the case of a police call did the deputies cross paths. From the looks of the photograph, things ended peacefully. Pictured from left to right are deputy Henry Stine, Captain Drinks, and deputy Buddy Garner. (Courtesy Buddy Garner.)

MOONSHINE WHISKEY DISPOSAL. In the mid-1950s, deputies Henry Albrittain and Robert "Cheese" Jameson stopped a car that was riding very low to the ground. Upon discovering the car was registered to a deceased person, they inspected the trunk to find 152 gallons of moonshine whiskey. The last arrest for moonshine in the county was made in the early 1970s. In the image, the sheriff's department disposes of the moonshine from the court case down the storm drain in the front of the county government building and high school. From left to right are Jimmy Vernon, standing; Robert "Cheese" Jameson, bent over; Buddy Garner, in truck bed; two unidentified; Henry Albrittain; and Jerome Jameson, county custodian and maintenance man. (Courtesy Buddy Garner.)

QUARTERMASTER FOR SHERIFF'S OFFICE. A young Charlie Thompson came on the force as a dispatcher at the age of 18. At 21, he became a deputy and rose to captain by retirement. As a civilian, he then returned as quartermaster for the department. His duties included the ordering and care of supplies. Pictured from left to right are Sheriff Buddy Garner and Charlie Thompson in the mid-1960s. (Courtesy Buddy Garner.)

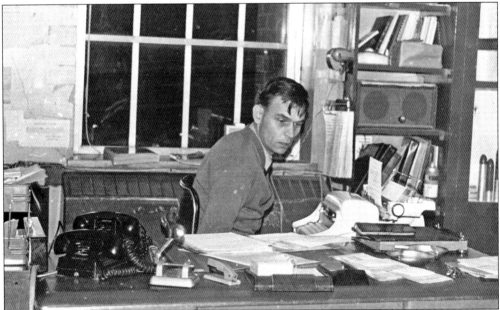

POLICE NIGHT SHIFT. The sheriff's office used to be located in the Charles County Courthouse. The sheriff's office did not have a clerk magistrate and the officers did all of the paperwork. One of the two phones, on the left side of the desk, was used as a police radio. The radio with two speakers on the second shelf to the right was to monitor state police calls. Pictured is Deputy Sheriff John Avery Monroe, who served from 1961 to 1985. (Courtesy Buddy Garner.)

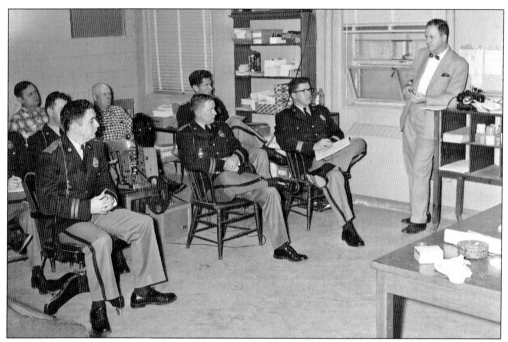

CRIMINAL INVESTIGATION CLASS. In the 1950s, FBI agents occasionally gave criminal investigation classes to the sheriff's department. Pictured from left to right are (front row) deputies Buddy Garner, Hank Moody, and Eddie Clements; (second row) Robert "Cheese" Jameson and Pete Cooksey; (third row) Jimmy Vernon and Julius Robey. The FBI agent's name is unknown. (Courtesy Headen Collection at SMSC, College of Southern Maryland.)

SHERIFF'S DEPARTMENT MANDATORY TRAINING, 1968. In 1968, law enforcement classes became available at the University of Maryland. Prior to that time, the sheriff's department received on-the-job training, with an older officer teaching a younger officer. Pictured at a class in the county commissioner's room of the courthouse are, from left to right, John Avery Monroe, Weldon Woods, Buddy Garner, Robert "Cheese" Jameson, and Pete Cooksey. (Courtesy Buddy Garner.)

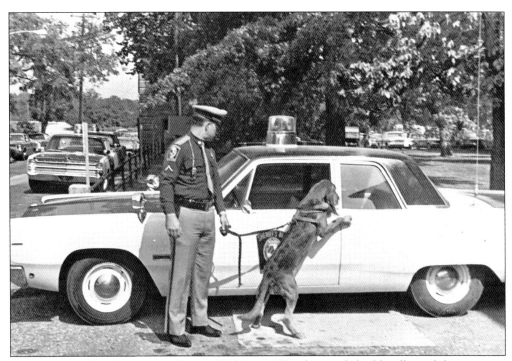

BLOODHOUND DOG PROGRAM. Deputy Weldon L. Wood started the bloodhound dog program for the Charles County Sheriff's Department in 1968 with Sherlock. In 1970, Wood joined the National Police Bloodhound Association and in 1975 won the coveted Joe B. Marcum Award honoring his individual contribution to the advancement of the man-trailing bloodhounds in law enforcement. Pictured are deputy Wood and Sherlock. (Courtesy Weldon L. Wood.)

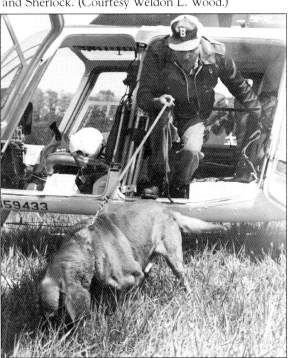

BLOODHOUND DOG EVIDENCE. Charles County sheriff's deputy William D. Brown emerges from a helicopter to demonstrate the bloodhound's ability to travel anywhere for a scent trail. In 1977, Brown was the handler for a bloodhound named Jake. Jake produced clues and evidence that were used in a case that went to the Maryland Court of Appeals and set a precedent that evidence discovered by bloodhounds could be used in court. (Courtesy Weldon L. Wood.)

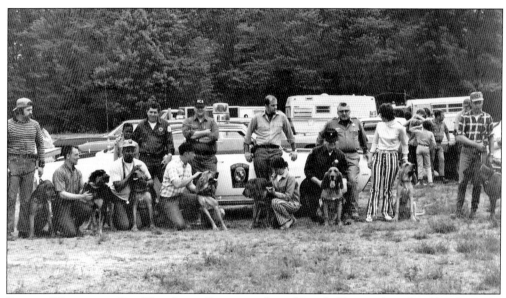

DEPUTY WOOD WITH BO. The phrase "being caught red-handed" is attributed to bloodhounds. In England, poachers tracked by bloodhounds were found so quickly that they were usually still dismembering their prey, so their hands were red or bloodstained. In 1971, the Charles County Sheriff's Department hosted a training session organized by deputy Weldon L. Wood. Pictured are various county and state police participants. (Courtesy Weldon L. Wood.)

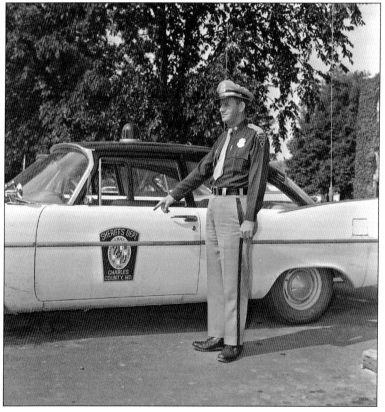

DEPUTY SHERIFF ROBERT "CHEESE" JAMESON. Robert became a deputy sheriff in 1955, went into military service in 1956, and then served as deputy sheriff from 1958 to 1978. In 1955, there were seven full-time deputies. By 1977, there were 60 deputies. Deputy Jameson is pictured pointing to new county decals in 1968. (Courtesy Headen Collection at SMSC, College of Southern Maryland.)

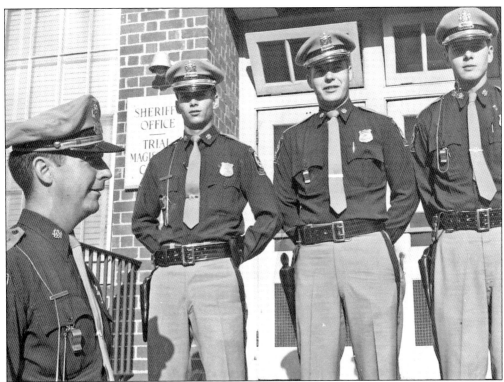

CHARLES COUNTY SHERIFF'S DEPARTMENT RECRUITS. These new recruits came on the force between 1964 and 1965. Pictured from left to right in front of the sheriff's office, located in the courthouse, are Sheriff Buddy Garner, Danny Ritchie, Bobbie Mudd, and Dave Fuller. Ritchie went on to work as a caretaker for the historic home at Chapman's Landing, Mount Aventine. Bobbie Mudd retired after serving 20 years, and Dave Fuller was sheriff from 1978 to 1986. (Courtesy Buddy Garner.)

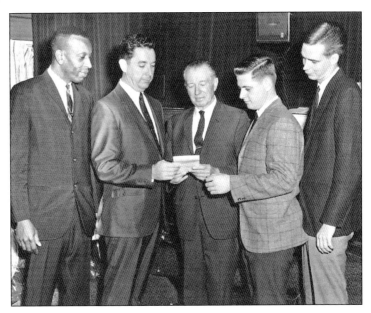

POLICE ACADEMY TRAINEES. Mandatory law enforcement training for the sheriff's department began in 1968. One of the first new trainees was honored in a dinner held at the Waldorf Restaurant. The speaker was Sen. Paul Bailey of St. Mary's County. Pictured from left to right are deputy Roland Dyson, Sheriff Francis C. "Buddy" Garner, Sen. Paul Bailey, and deputies John Wood and Dave Gladwell. (Courtesy Buddy Garner.)

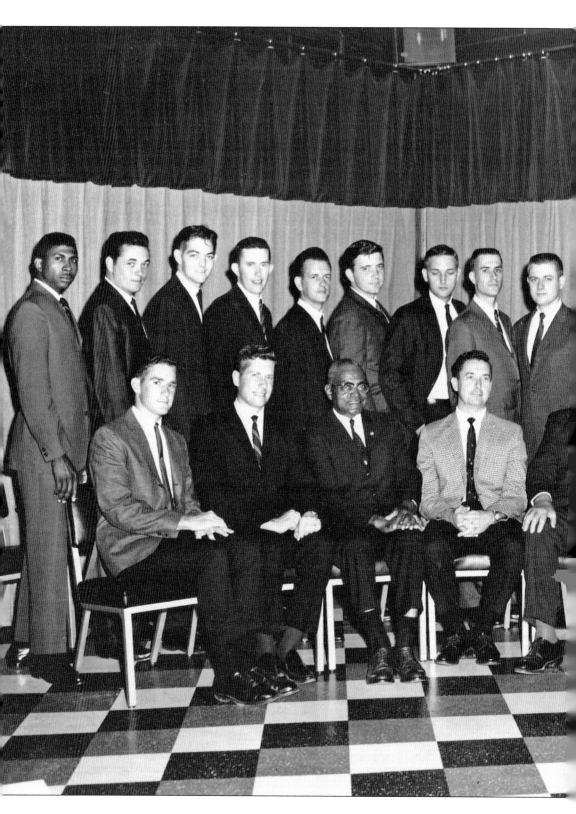

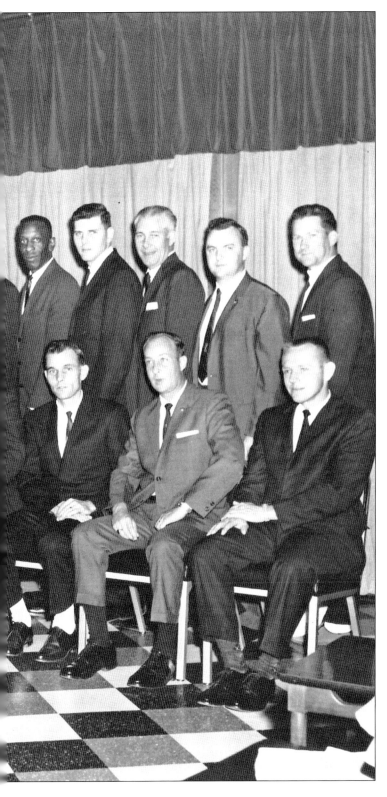

Sheriff's Deputy Retirement. In 1968, two sheriff's deputies retired, James "Chief" Woodland and Henry Bettinson Albrittain. They each received shotguns as valediction gifts. Henry Albrittain was a town policeman prior to being a sheriff's deputy. James "Chief" Woodland was the second full-time African American on the Charles County force. The event was held at the Waldorf Restaurant. Pictured from left to right are (first row) Charlie Thompson, Rupert "Pete" Cooksey, James "Chief" Woodland, Sheriff Francis C. Garner, Henry Bettinson Albrittain, John A. Monroe, Donald Poole, and William Norris; (second row) Henry Tolson; James Gartland, who later became sheriff; Max Boland; Storm Hutchinson; George Wright; Ross Petrelli; Alan Harper; Tommy Scoffield; John Wood; Bobby Mudd; Roland Dyson; Dave Fuller, who later became sheriff; Tommy Canter; Billy Poole; and Weldon Woods. (Courtesy Hutchinson Collection.)

JUDGE JAMES C. MITCHELL. After serving in World War II as a major on the staff of the judge advocate general of the U.S. Army, Charles County native Mitchell returned to practice law. He was also publisher and editor of the *Times-Crescent* in 1934 and served the newspaper until 1969. In 1970, he was appointed associate judge of the 7th Judicial Circuit and was then elected judge to a 15-year term in 1972, but he was required to retire at age 70 in 1975. He had time to serve as chairman of the board of trustees of Charlotte Hall School, was an advisory board member of the Maryland National Bank, honorary member of the Rotary Club, member of the Charles County Farm Bureau, and gave time to the American Cancer Society. He passed away at his boyhood home, Thainston, in 1989 and is remembered as being an honest man. (Courtesy Courtenay Wilson.)

Seven
LITTLE LAS VEGAS

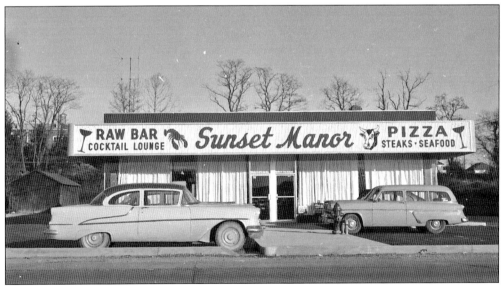

SUNSET MANOR, LA PLATA. M&H Engineering, Middleton Plumbing, and Higdon Electric, were all originally in this building constructed in 1946 on Route 301 in La Plata. They added new office space onto the back and leased the front part to Phil Gray Enterprises, which created the restaurant and bar that offered slot machines as entertainment from the 1940s until the 1960s. Gray was instrumental in helping several businesses on what was called "the strip." (Courtesy Headen Collection at SMSC, College of Southern Maryland.)

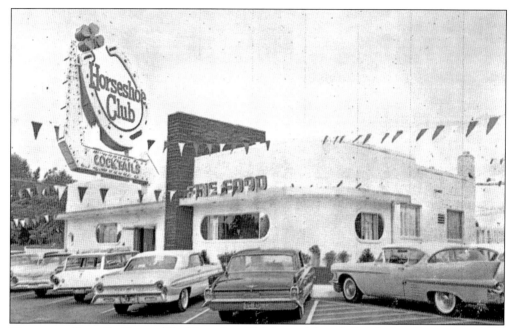

HORSESHOE CLUB, LA PLATA. The Horseshoe Club began life as Sollie's Italian Restaurant. After 1949, slot machines were legalized and the Horseshoe Club employed them in their swanky restaurant and cocktail lounge. After 1969, when the slot machines were phased out, Richard "Dickie" Chaney of Chaney Enterprises bought the restaurant and added a barbecue pit. It is now home to Johnny Boys Barbecue. (Courtesy Dottie Crecelius.)

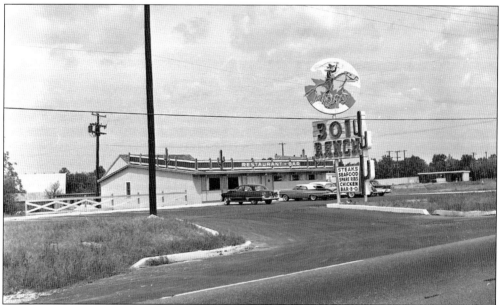

301 RANCH IN WALDORF. The restaurant sat at the busy intersection of Berry Road and Route 301. The round part of the neon sign spun around to attract gamblers. Live music was offered seven nights a week and featured musical performances by young groups like the Bobby Lester Band. Behind it and to the left was the screen for the Waldorf Drive-In Theater. The property is now the location of a Circuit City. (Courtesy Headen Collection at SMSC, College of Southern Maryland.)

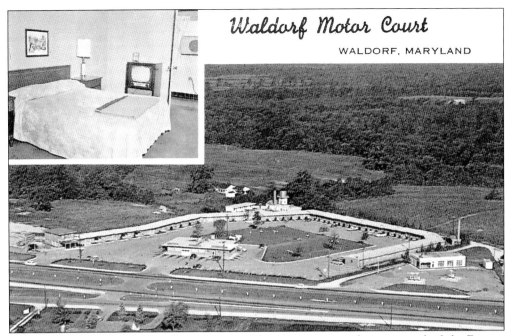

Waldorf Motor Court and Restaurant. The motor court and restaurant, built by Eugene "Babe" Chaney Sr. in 1950, was originally one story with 15 motel rooms. Both the motel and restaurant were increased to two stories in 1957. The upper level of the restaurant was the Loft Room, where dancing was offered six days a week. A bar, food buffet, and slot machines provided additional entertainment. After the slot machines were phased out in 1949, it became a supper club. The first-floor restaurant operated around the clock seven days a week. Pictured above is the one-floor motor court and restaurant before 1957. Pictured below is the restaurant with the second-floor Loft Room after 1957. (Both, courtesy Dottie Crecelius.)

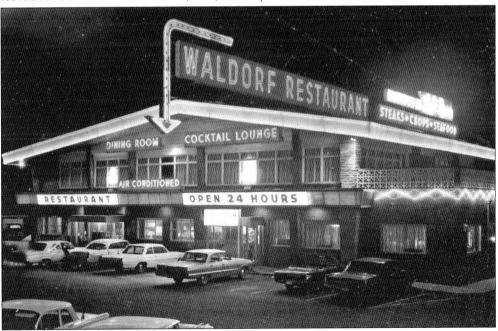

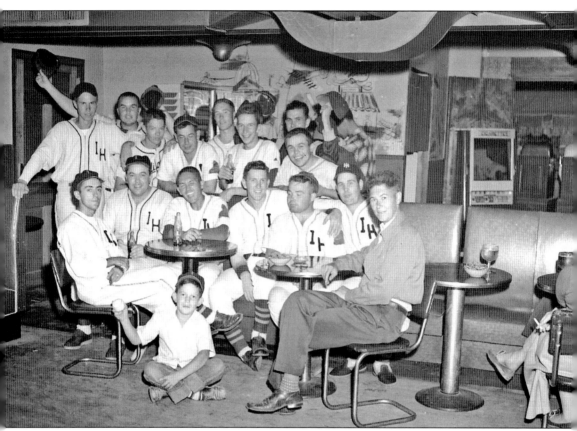

THE CLUB MARYLAND. Slot machines were installed in even the smallest establishments during that era. Pictured is the Indian Head Baseball team, champions of the Southern Maryland baseball series of 1953. From left to right are the following: (first row) Lenny Stillson, David "Mooch" Byrd, Charlie Wright Jr., Charlie Nairn, Lewis Shelton, Gene Shelton, and fan Kenneth Buck; (second row) Floyd Buck, Jack Byrd, Chuck Simmons, Fred Welch, John Bloom, Eddie Tucker, John Thomas Parran (who is partially obscured), and Johnny Byrd. The batboy is Jackie Shelton. (Courtesy Headen Collection at SMSC, College of Southern Maryland.)

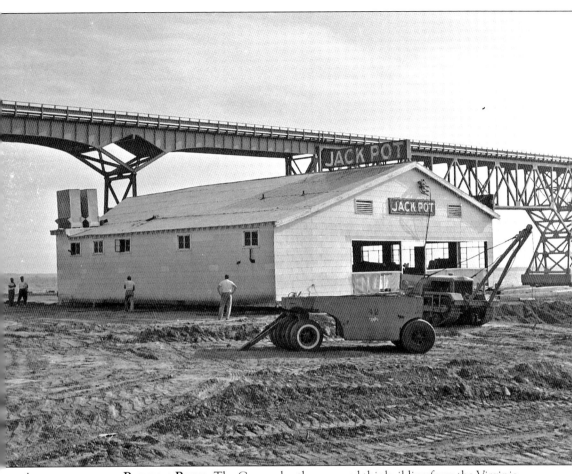

AQUALAND ON THE POTOMAC RIVER. The Conner brothers moved this building from the Virginia shoreline and placed it at Newburg when Maryland legalized gambling in 1949. The establishment was known for high-stakes poker and slot machines. Aqualand also featured a storybook land for children, picnic grounds, and an airport. The Reno Diner, at the end of the runway, offered fine dining and wild game dinners every night. (Courtesy Headen Collection at SMSC, College of Southern Maryland.)

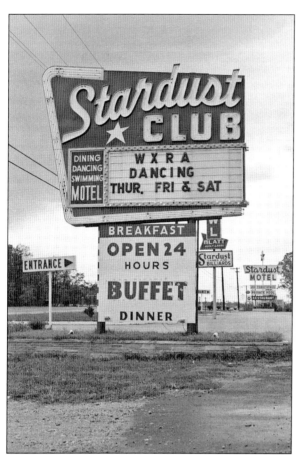

STARDUST CLUB OF WALDORF. Owned by five out-of-state partners, the Stardust was the largest club in Charles County and drew the biggest names in entertainment to their Starlight Room, such as Guy Lombardo, Peggy Lee, Jimmy Dean, and Conway Twitty. Initially the club featured a ballroom, but a lack of interest caused the partners to change it into a bowling alley. After the gambling era, Dave Williams from Cellar Door Productions leased it and continued to book entertainment until the early 1980s. Pictured at left is the colorful neon sign that gave the strip its Vegas feel. Pictured below is the Charles County Concrete bowling league in the 1960s at the Stardust. From left to right are Eugene Chaney Jr., Richard Chaney, Bob Hall, ? Tucker, Ernie Moore, Tom Goldsmith, and William "Whitey" Roberts, manager of the Waldorf Motel and Restaurant. (Left, courtesy Headen Collection at SMSC, College of Southern Maryland; below, courtesy Roberts Collection.)

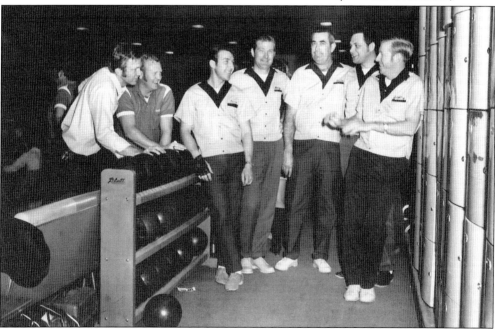

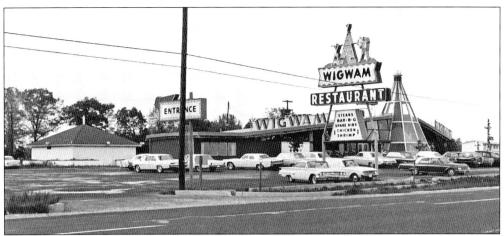

WIGWAM LOUNGE. The lounge was an early establishment along the newly built Route 301. Bands like the Versatiles played in the glass tepee part of the popular nightclub. The lounge showcased bands that played rock and roll and country. In the 1960s, even a topless all-girl band played there. The Wigwam was also known to have the best ham sandwich in the county at a cost of 50¢. When the slots went out in 1969, the lounge turned into a go-go bar that featured a platform in the glass tepee where the girls could be seen performing from the highway. The Wigwam Lounge was home to Walls Bakery from mid-1970s until the late 1990s. Pictured above is the Wigwam in the 1950s, and pictured below is the lounge interior. (Both, courtesy Headen Collection at SMSC, College of Southern Maryland.)

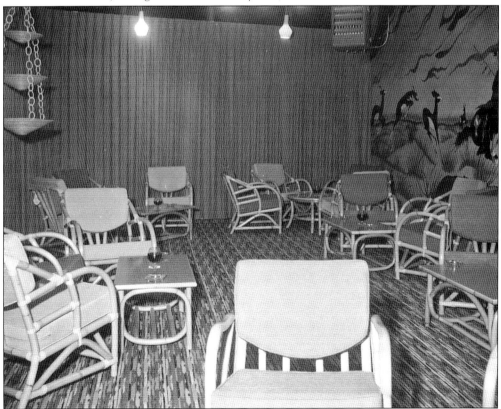

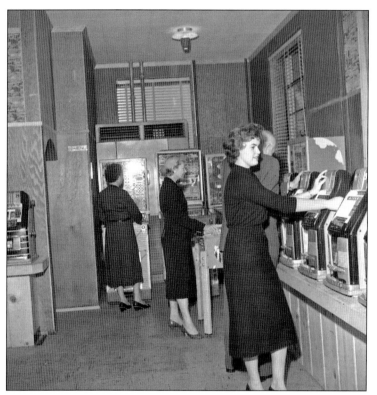

301 Restaurant and Bar. Joseph Sipers remodeled the inside of his large La Plata establishment in 1958. He added a large neon lobster sign to help advertise a live tank from which hungry customers chose their dinner. Pictured in the right foreground playing a slot machine is Marilyn Cox Hancock. Slot machines were in every establishment in Charles County, including gas stations, laundromats, and grocery stores. (Courtesy Headen Collection at SMSC, College of Southern Maryland.)

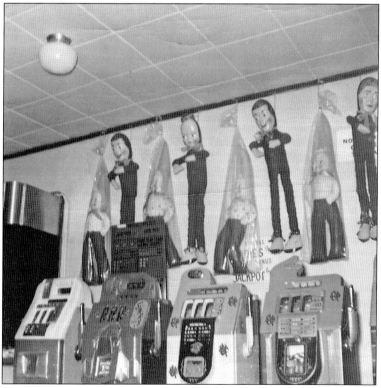

Slot Machines. The Mills Machine Company in Chicago manufactured the slot machines pictured. The bodies were metal and came in a rainbow of colors. The first two pictured from left to right are high-tops, the third is a half-top, and the last is a fish-mouth. The handle is called a sword handle. In the 1950s, machines had a longer handle with a ball on the end, called the ladies handle, for easier play. (Courtesy Roberts Collection.)

Eight
INFRASTRUCTURE

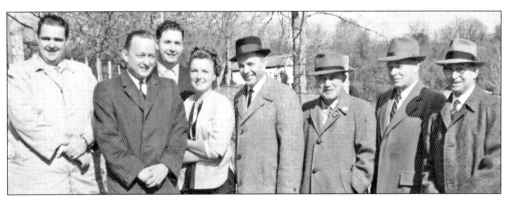

CHARLES COUNTY CORNERSTONES. In the early 1960s, this hardworking assembly took a moment out of their busy schedules to be photographed. Pictured from left to right are Dennis Maloney, judge of the orphans court; George Zverina, attorney for the county commissioners; Sheriff Buddy Garner; Loretta Nimmerichter, delegate; Nat Noel Dotson, county commissioner; Judge Crist; Julius Robey, sheriff's deputy who became a county commissioner; and Algie Cooksey, president of the county commissioners. (Courtesy Buddy Garner.)

PHYSICIANS MEMORIAL HOSPITAL. The first hospital in Charles County was built in 1938, when public outcry escalated after the hurricane of 1926. Prior to that, residents had to travel to a Washington or Baltimore hospital for serious medical treatment. In 1936, the Roberts family donated the land for the hospital, and initial pledges of $12,000 were obtained from locals to begin the building process. The 21-bed hospital was dedicated on January 2, 1939, and offered 24-hour service with two physicians providing service on a rotating basis. Within the first five weeks, 56 patients were admitted, with 14 for major surgery, eight maternity cases, and a few cases of pneumonia. A larger hospital was built across the street in 1963, and the Charles County government uses the old hospital. Pictured above is the first hospital under construction, and pictured below is the finished building. (Both, courtesy Civista Medical Center.)

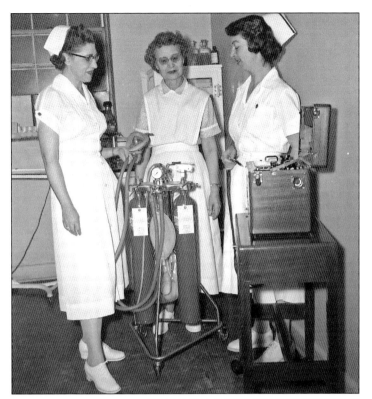

OPERATING ROOM EQUIPMENT. Community groups provided equipment such as the air mask for the operating room seen in the photograph. Supporting branches, such as the Women's Auxiliary of the hospital, would mend hospital linens and gowns to keep operating expenses down. Pictured from left to right are Leona Mates, p.m. supervisor; ? Goldsmith; and Lois Post. (Courtesy Headen Collection at SMSC, College of Southern Maryland.)

CHARLES COUNTY PUBLIC LIBRARY BOOKMOBILE. The bookmobile was purchased in February 1951, and it carried about 1,200 books. In 1964, a new bookmobile was purchased, and the old one was set on cinder blocks and used as a book station in Waldorf. Pictured from left to right are P. D. Brown, Frank Wade, and an unidentified driver. (Courtesy Headen Collection at SMSC, College of Southern Maryland.)

SOUTHERN MARYLAND MINUTEMEN. During World War II, these men were reserved militia from the 5th and 9th Companies. It was unusual for the reserved militiamen to have uniforms. This group was from and around the La Plata area. Pictured at their annual crab feast in 1945 are (first row) Harold Hancock, Ferdinand Cooksey, Harold Cooksey, Frank Hamilton, Billy Moreland, John Matthews, Nelson Perry, Carroll Morgan, and Roy Greer; (second row) Carl Cooksey,

Jimmy Murphy, Victor Bowling, Joe Scott, Johnny Greer, Bob Morgan, Otis Barnes, James Matthews, and Robert Nalley; (third row) C. Jones, Howard Rison, Wills Posey, Roy Reed, Thomas P. McDonagh, Harold McDowell, Calvin Compton, Leonard Matthews, and Albert Campbell. (Courtesy Cooksey Collection.)

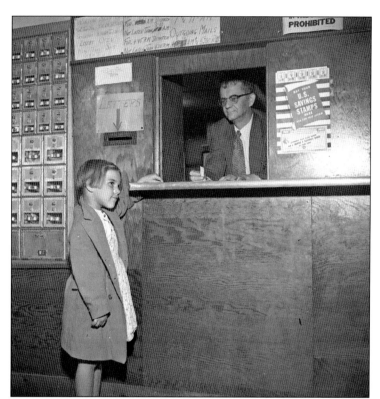

OLD WALDORF POST OFFICE. Prior to 1957, post offices in Waldorf were located in general stores. The sign to the right of postmaster W. Louis Ryon is an advertisement for U.S. savings stamps, or war stamps. The stamps cost 10¢ each and were collected in a book that, when full, was valued at $18.75, enough to buy a bond. The little girl is Pat Baker Smith. (Courtesy Headen Collection at SMSC, College of Southern Maryland.)

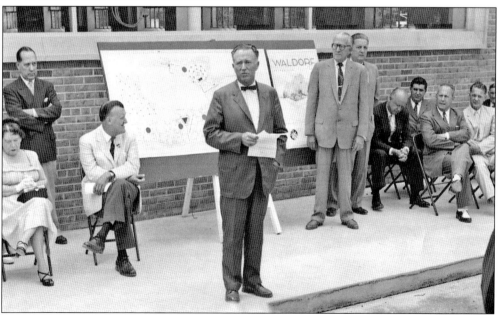

NEW WALDORF POST OFFICE. The first freestanding post office opened on September 2, 1957, at a cost of $70,000. It was located on Route 5 and was built to handle mail for 1,100 families. Pictured at the dedication ceremony from left to right are Louise Monroe; James B. Monroe, commissioner of the Maryland MVA; Governor McKeldin; master of ceremonies and former Sen. Paul J. Bailey; and various state officials to his right. (Courtesy Joe Boswell.)

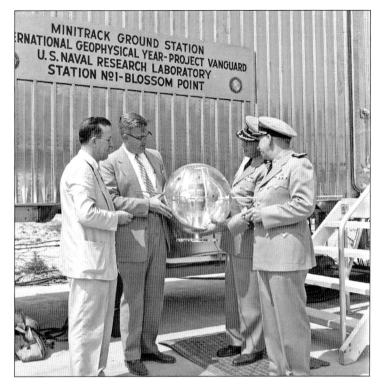

BLOSSOM POINT TRACKING STATION. Blossom Point was an army installation firing range that also housed a naval tracking field site. In October 1957, the big news at the station was tracking the Russian satellite Sputnik. During the 1950s, the tracking range only ran from the 75th meridian from Washington, D.C., to Santiago, Chile. It is still in operation as an army research laboratory. All are unidentified. (Courtesy Headen Collection at SMSC, College of Southern Maryland.)

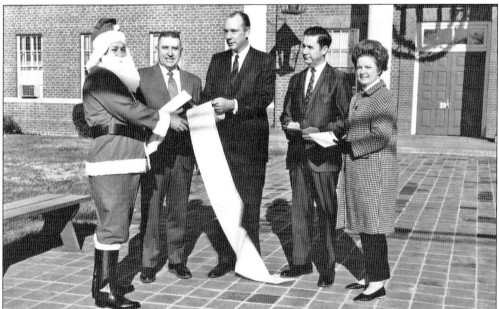

ELECTED OFFICIALS CHRISTMAS LIST. In 1967 and 1968, Charles County leaders petitioned Santa for some goodly benevolence for their citizenry. Pictured in front of the La Plata Courthouse from left to right are Santa Claus; Calvin Compton, member house of delegates; Reed McDonagh, Charles County commissioner president elect in 1966; Sheriff Buddy Garner; and Loretta Nimmerichter, member of the house of delegates. McDonagh was appointed deputy director of the newly established Maryland Environmental Service in 1970. (Courtesy McDonagh Collection.)

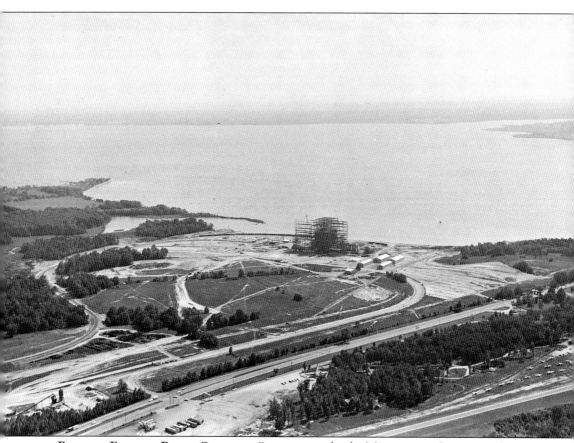

POTOMAC ELECTRIC POWER COMPANY. Construction for the Morgantown Generating Station on the Potomac River near the Harry Nice Bridge started in the spring of 1967. The original structure consisted of two coal-fired units, one completed in 1970 and the other in 1971, and the plant originally consisted of 427 acres. Pepco no longer owns the plant, and it was sold to Southern Energy, Inc., in 2000 and is now owned by Mirant Corporation. The power plant still runs on coal that is delivered by train on the once-commercial train line that brought life to Charles County in 1873. Pictured is the plant under construction, and to the far right is the Aqualand airport. (Courtesy McDonagh Collection.)

Nine
LOCAL PERSONALITIES

VERNON FAMILY OF WALDORF. Sam Vernon married Grace Hamilton in 1915 and shared over 67 years of marriage. They owned a small tobacco farm on Vernon Road, but Sam evolved into a livestock huckster, or middleman. Sam bought from local farmers and sold to meat merchants in Washington. Pictured from left to right are Sam Vernon, Elsie Richards, Ritchie Vernon, Sam Vernon, Grace Vernon, Charles Vernon, and May Howard. (Courtesy May and Rose Howard.)

SHEA FAMILY OF TOMPKINSVILLE. Michael Shea came to Charles County in 1900 from Ontario by way of Hollywood, California, where he was a foreman on the Irvine Ranch. While passing through Maryland, he bought a 110-acre farm on the Wicomico River for raising cattle and grain crops and operated a general store. He soon met and married Marie Norris, a Wayside native and schoolteacher. The children in the 1906 photograph are Earl and Gladys. (Courtesy Nalley Collection.)

LA PLATA BICYCLE GANG. The Washington Avenue neighborhood kids were very fortunate to own bicycles in 1944 in the rubber shortage due to World War II. Pictured from left to right are Sonny Posey, who became owner of Posey's Hardware Store; Jackie Clark; Jimmy Baer, who is kneeling; Tom Posey, who became a land developer; Bobbie Fennell; Bobbie Farrall, part owner of Baldus Real Estate; Jimmy Hicks; and Anna Lee Lorenze. (Courtesy Baldus Collection.)

MARYLAND ATHLETIC COMMISSIONER. Thomas Patrick McDonagh held a few world records in track-and-field from 1910 to 1930. He was an athletic commissioner from 1939 into the 1950s. The commission supervised all boxing and wrestling matches held in the state of Maryland. Pictured from left to right are McDonagh and great heavyweight champion Joe Lewis at a bout Lewis won against Jimmy Bivins in Baltimore. (Courtesy McDonagh Collection.)

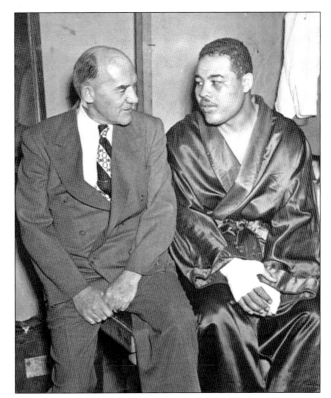

LEONARD BENDER. Leonard represented the Catholic Notre Dame School in Bryantown for the oratorical contest of 1953. Leonard's subject was "Christ's Challenge to You." It was noted in his yearbook that he possessed a friendly, sincere nature. His accomplishments included being on the National Honor Society, Athletic Association president, in student council, varsity basketball team, and "blazer" boy, a nickname for the school's most athletic. Leonard is pictured standing on stage. (Courtesy Bender Collection.)

CHARLES TOWN RACE WINNER. Jockey Bill Hartack launched his hall of fame career at Charles Town in 1952. In July 1958, Peter Vischer entered his racehorse, Arch Rival, in a four-and-a-half-furlong race and won a $1,500 purse. Vischer owned Habre de Venture at the time. Pictured from left to right are "Fatso;" Lawrence Brown, owner of the Charles County historic home Western View; Peter Vischer; and two unidentified. (Courtesy Abell Collection.)

MCDONAGH CHEVROLET SERVICE MECHANICS. These men pictured in their Chevrolet service uniforms all worked at McDonagh Chevrolet in La Plata. Pictured from left to right are (front row) Bob Simpson, Dick Landry, John Thir, and Fleet Lee; (second row) Charles Briscoe, Horace Wallace, Johnny Dyson, Ed Moyer, Jerry Rison, and Roland Dyson. (Courtesy McDonagh Collection.)

CARLIN "WESTLEY" PENNY. Henry's Photography Studio was located on Pat and GeeGee's Tavern property on Route 925 in Waldorf. The studio was in a travel trailer parked near the road. Since the Pennys lived above their tavern, their son Carlin was always dressing up and going over to get a photograph snapped. Carlin eventually went to work for the Washington, D.C., Sanitation Department in Upper Marlboro. He still likes to dress up for special occasions. (Courtesy Penny Collection.)

BALDUS FAMILY. In 1968, the first out-of-state vacation for the Baldus family was to an American Farm Managers and Rural Appraisers convention in Flagstaff, Arizona. Carl Baldus started managing farms and appraising real estate. He was certified and became a real estate broker in 1960. Bobbie, also a realtor, became a broker in 1970. Pictured from left to right are Carl, Teri, Bobbie, Rick, and Bonnie Baldus. (Courtesy Baldus Collection.)

BENJAMIN FRANKLIN BOWIE. The Bowie family of Pisgah, William Thadeus and Elizabeth Rosetta Welch Bowie, adopted Benjamin Franklin Bowie. Benjamin and wife, Mary Elizabeth, became owners of Oakland Farm in Welcome. Part of the farm was later deeded off to son Benjamin Franklin Jr., which became Goose Bay Marina. Benjamin Sr. also owned the Atlantic Gas Station in Waldorf, sawmills, and heavy equipment, and was a deputy at Marshall Hall Amusement Park during the slot machine era in the early 1960s. (Courtesy Olive Bowie Perry Collection.)

CHARLES RUSSELL PERRY JR. Walter and Nanny Mills of Grayton raised Charles when his parents died. He served as mailman during World War II in the South Pacific on the USS *Blessman*. He married his second wife, Olive Bowie of Welcome, in 1972. After returning home he was a plumber for the Indian Head Naval Ordinance Station, salesman at the Mitchell Supply Company, Charles County government building inspector, and then a part-time Indian Head government building inspector. (Courtesy Olive Bowie Perry Collection.)

JOSEPH WILLIAM BOWIE. In the 1940s, Joseph was in the army and stationed in Texas, but he never went to war. He came home to help his father, Benjamin Franklin Sr., owner of Oakland Farm. He married Ethel Marie Simpson of Welcome and had one son, Joseph William Jr. He owned the Atlantic service station in La Plata that is now the La Plata Tire Center on Route 301. Joseph Jr. is now part owner of Goose Bay Marina. (Courtesy Olive Bowie Perry Collection.)

Ten
RECREATION

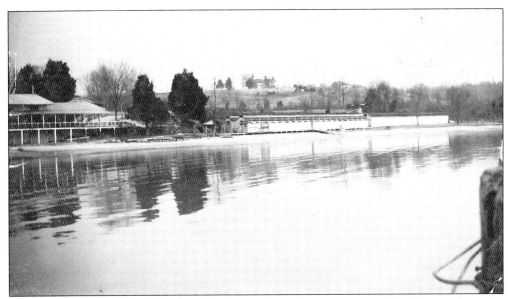

CHAPEL POINT PARK. In 1926, B. B. Wills leased riverfront acreage on the Potomac from the Jesuits of St. Ignatius Church in Bel Alton, and opened the park that featured a picnic grounds and bathing beach. Pictured is the view of the beach in the 1940s, with bathing houses on the right. The two-level pavilion on the left was used for dances and skating. On the hill in the background is St. Ignatius Church. (Courtesy Rice Collection.)

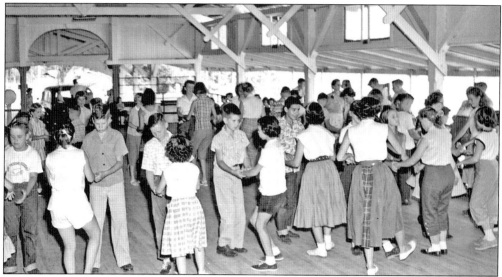

CHAPEL POINT PARK. In 1956, Chapel Point was advertised as Southern Maryland's favorite summer playground and offered a roller skating facility, swimming beach, water skiing, boats for hire, and a dance orchestra every Saturday evening. By the 1970s, the park closed. Pictured above is a teen dance in the pavilion. Milt Grant would often host a record hop during the 1950s. (Courtesy Headen Collection at SMSC, College of Southern Maryland.)

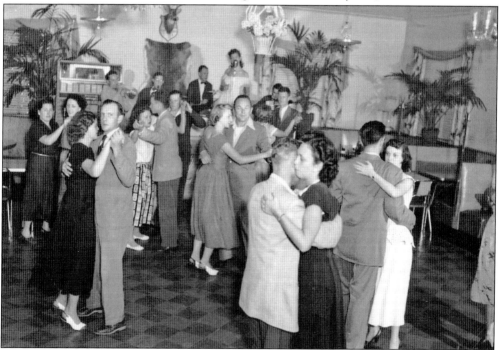

HOTEL CHARLES. Ole Olson built his first two-story wood frame hotel and bar in 1936. After a devastating fire, it was rebuilt with brick and declared an official emergency shelter for the Hughesville area. Saturday night dances were popular with live music. In 2003, it was bought by Jeff Thomas and Joe Jones and is still in operation. Pictured is the dance floor with booths, which are still in use, lining the walls. (Courtesy Thomas/Jones Collection.)

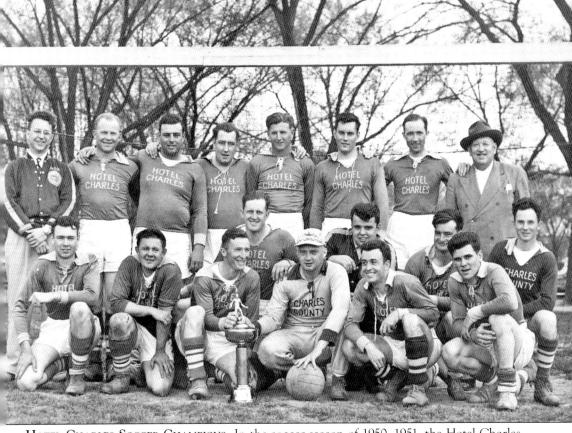

Hotel Charles Soccer Champions. In the soccer season of 1950–1951, the Hotel Charles team reigned as champion of the Washington and Suburban Soccer League. In the winning game, J. C. Hancock was in the goal; Bob Mitchell and Ole Olsen were fullbacks; Frank Bowling and Chester Hancock were halfbacks; Bobby Gray was center halfback; James Rollins and Freddie Hardesty were wings; John Matthews, Jesse Turner, and Russell Levering were on the line; and substituting were Wilbur Hancock, Harold Cooksey, Buck Baden, and Dutton Elder. The team was managed by J. Oden Turner and sponsored by Ole Olson. Pictured is the entire Hotel Charles team in no particular order. Team sponsor and owner of Hotel Charles, Ole Olson, is the last man standing on the right. Coach John C. Hancock is kneeling to the right of the trophy. (Courtesy Cooksey family.)

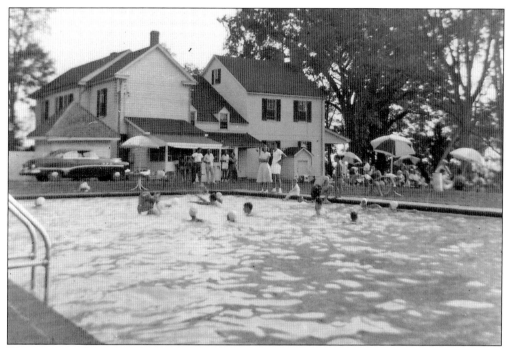

HAWTHORNE COUNTRY CLUB, LA PLATA. The private country club in Southern Maryland was founded in 1948 as a hunt club. The house that came with the property was refurbished and membership amenities included tennis courts, children's playground, skeet shooting area, croquet, badminton, archery, cards, billiards, and ping-pong. A pool was added in 1951 and a golf course in 1962. Pictured is the original clubhouse, destroyed in 1972 to make way for a new one. (Courtesy Baldus Collection.)

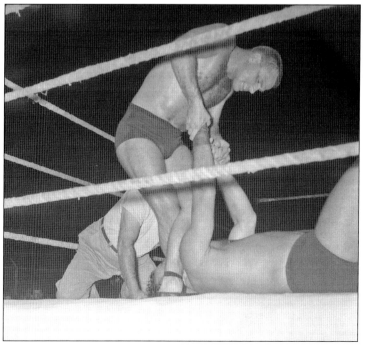

WRESTLING MATCH. The National Guard Armory was host to many wrestling matches in the 1950s. Top billers were Antonino Rocca versus Karl Von Hess and Ricki Starr versus Danny McShain. Other performers were Jackie Nichols and Big Jim Bernard. General admission cost $1.50, while ringside cost $2.50. (Courtesy Headen Collection at SMSC, College of Southern Maryland.)

301 DRIVE-IN, WALDORF. *God's Little Acre* was the first picture shown at the newly opened drive-in on June 26, 1958. The snack bar offered Italian meatball sandwiches and shrimp rolls. There was also a large outdoor patio for watching the movie if one wanted to be social. Later in the summer of 1958, Cecil B. DeMille's the *Ten Commandments* played at the drive-in. (Courtesy Headen Collection at SMSC, College of Southern Maryland.)

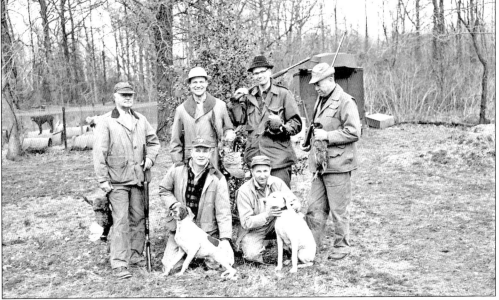

PHEASANT HUNTING. Charles County was known for its abundant wild game. In 1958, a group of congressmen had success at Joe Tucker's pheasant farm. There was also a pheasant farm in La Plata owned by Mitch Digges. Pictured from left to right are (first row) Joe Tucker and Mitch Digges; (second row) John Pilcher of Georgia, Henry Reuss of Wisconsin, John Dingell of Mississippi, and Phillip Landrum of Georgia. (Courtesy Headen Collection at SMSC, College of Southern Maryland.)

Discover Thousands of Local History Books
Featuring Millions of Vintage Images

Arcadia Publishing, the leading local history publisher in the United States, is committed to making history accessible and meaningful through publishing books that celebrate and preserve the heritage of America's people and places.

Find more books like this at
www.arcadiapublishing.com

Search for your hometown history, your old stomping grounds, and even your favorite sports team.

Consistent with our mission to preserve history on a local level, this book was printed in South Carolina on American-made paper and manufactured entirely in the United States. Products carrying the accredited Forest Stewardship Council (FSC) label are printed on 100 percent FSC-certified paper.